THE ART OF Showing Art

JAMES K. REEVE

REVISED AND UPDATED

Council Oak Books

Council Oak Publishing, Inc.
Tulsa, OK 74120

Manufactured in the United States of America

96 95 94 93 92 5 4 3 2 1

Library of Congress Catalog Card Number 86-61319
ISBN 0-933031-67-x

To the memory of my parents
in appreciation of their
encouragement and support.

CONTENTS

ACKNOWLEDGEMENTS

THE INFORMATION CONTAINED IN *THE ART OF SHOWing Art* was gleaned over a period of thirty years of displaying artworks in museums as well as occasionally in private homes and offices. Five years ago, when I decided to leave a museum directorship to open a private art consultancy practice, a number of friends and colleagues suggested that I write down the rules and procedures I had developed regarding the installation and display of art objects. The methods I used enabled me, working alone or with only a few assistants, to install an attractive exhibition in a matter of two or three working days, whether the display contained a couple dozen works or several hundred.

My first museum position was as a lecturer at the Museum of Modern Art in New York City. I learned that the beautifully displayed works comprising the museum's handsome, famous exhibits were arranged to quietly educate the audience. I was given the great opportunity of observing the various departmental directors when they supervised exhibition installations. I once watched Alfred Barr arrange five masterpieces by Vincent van Gogh. Mr. Barr spent two hours making painstaking adjustments to the positions of the five works, but when he finished, the paintings were perfectly displayed.

Since that time, I have made an analysis of the raison d'être of the display objects in any exhibitions I have seen in museums, commercial galleries, offices, restaurants, stores, and private homes. I would like to be able to say that I have always been pleased, but, unfortunately, too many times I've been dismayed by the lack of interest or ability in presenting the artwork so as to enhance its quality and give the viewer added pleasure.

I am indebted to many sources whose primary influence enabled me to develop an understanding and knowledge of the audience's psychological responses to the optimum presentation of art for public and private viewing. I am deeply grateful to Martin and Margaret Wiesendanger and to Alexandre Hogue for first making me aware of the pleasures to be derived from a knowledge of great art. The late Professor Martin Weinberger of New York University's Institute of Fine Arts guided me through the maze of museum exhibition tactics

and techniques. The exhibition staff at the Museum of Modern Art from 1950 through 1954 allowed me to observe them in operation and so taught me the basis of premier museum exhibition.

Gratitude is expressed to Otto Wittman, now Director Emeritus of the Toledo Museum of Art, and to Rudolph M. Riefstahl for encouraging me to expand my abilities in major exhibition installation procedures. I also wish to thank Mr. Riefstahl for examining this manuscript from the point of view of a professional conservator. His astute criticisms and suggestions regarding the technical and scientific aspects of conservation of artwork have been most helpful.

Museums with distinctive solutions to problems of display that have had direct, pertinent bearing on the development of my style of art presentation include the Toledo Museum of Art, the Art Institute of Chicago, the Cleveland Museum of Art, Colonial Williamsburg, the Museum of Science and Natural History in Kansas City, the Nelson-Atkins Gallery in Kansas City, the Timkin Pavilion in San Diego, the Getty Museum in Malibu, the Denver Art Museum, and the Freer Gallery in Washington, D.C. Foreign museums include the Krohler-Müller Museum and Sculpture Garden near Arnhem, Holland; the Stedlijk and Van Gogh Museums in Amsterdam, Holland; the Archaeological Museum in Aarhus, Denmark; the Gulbenkian Museum in Lisbon, Portugal; the National Gallery of Scotland in Edinburgh; the Uffizi Gallery in Florence, Italy; and the Archaeological Museum in Luxor, Egypt.

I am also deeply indebted to and gratefully appreciate the encouragement and assistance offered by numerous friends, especially Alice Lindsay Price and Ann E. Weisman for their perceptive suggestions and enlightened editing of the text, and to Mary Elizabeth Key, Beverly Soroka, and Dr. Alvin O. Turner for serving as "guinea pigs" by reading the finished work in manuscript form and relaying their impressions.

PREFACE

The Art of Showing Art focuses attention on those art objects we collect for their beauty, then so often dump into a living or working space. If you have artworks you want to show, how do you know the right way to arrange them? Designing the effective placement of objects is an easily learned art. Starting with the basics, *The Art of Showing Art* will lead you, step by step through a systematic method, to solutions for your display problems. Through this progression, you will become proficient at the art of showing art.

All of us are creative in varying degrees. Some of us have no trouble making our surroundings look pleasing to most who view them. Pictures, sculpture, decorative items, and furniture seem to look natural and right when some fortunate persons have a go at doing the arrangements. Then there are others of us who yearn for that proper look but seem to have little success in achieving it. Unfortunately, this group seems to be in the majority. The numerous assignments for basic arrangement of objects, excluding changes in furniture or color, received by interior designers attest to our lack of confidence or skill in creating displays.

The arrangement of objects in our environment is an art, and art is a form of communication. We use art to communicate in a subtle way the very essence of our existence. Virtually everything we use in daily living — the furniture we sit on or the decor, appliances, and utensils we use — can be classed as art since it communicates some aspect of our personalities.

Everything man-made is designed. Buildings, television sets, automobiles, and sculpture were all designed by artists, whether they are applied artists (architects, industrial designers, or engineers) or creators of fine art, such as sculptors. Because we are familiar with designed objects, we assume we know how to use them in our environments. We have learned to be aware of them by experience and by schooling, yet we are assaulted daily with visual stimuli through television, movies, packaged goods, traffic signs, and by our interior and exterior environments. With so much visual clutter, we may tend to tune it all out. The more we become unaware of our surroundings, the more difficult it is to create a visually satisfying

effect in those surroundings.

As a good or poor musician can make or ruin a piece of music, so too can the display of a work of art make it seem marvelous or mundane. Because most of us are sensitive to the effect we want to achieve by showing art, we usually know when it is in the wrong place even if we don't know where the right place is. *The Art of Showing Art* draws attention to the visible and recurrent problems and offers solutions to them. Obviously the solutions given here are not the only ones that can be applied, but they will serve as guidelines and will help point out the major trouble spots and how to overcome them.

Keeping in mind that the art of showing art is an art in itself, you can find an exciting adventure in store for you. Effectively displayed art can enrich your life, become a source of pleasure for you and your friends, and provide a sense of satisfaction and achievement. You may also become more aware of the many presentations of art in your community. Knowing how to advantageously display any work of art gives you a confidence and an accurate basis for judgment.

Enjoy *The Art of Showing Art* and have fun with your projects.

James K. Reeve

BASIC CONCEPTS

CHAPTER ONE

Composition
Compositional Direction
Subject Matter
Impact Interest
Visual Weight
Color
Visual Mass and Spacing

■ BASIC CONCEPTS

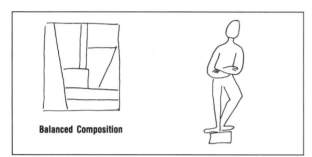

Fig. 1

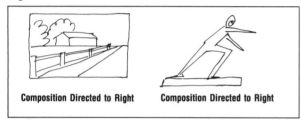

Fig. 2

COMPOSITIONAL DIRECTION

Fig. 3

■ WHEN AN ARTIST CREATES A WORK OF ART, HE OR she communicates with the eventual viewer by means of a series of elements. These elements are **subject matter, color, textural handling,** and **composition.*** Composition consists of the manner in which the other elements are put together and is the principal means by which the communication is made. Artists usually balance the composition in a given work. **Balanced composition** means that there is no special emphasis to right, left, top, or bottom (fig. 1).

However, the artist may wish to place special emphasis in one direction or another. When this is done, the resulting composition is said to have **compositional direction** (fig. 2). An artwork or group of artworks with compositional direction can pose subtle problems when put on **display,** or exhibit, because it subliminally diverts the viewer's attention away from the work of art in the direction toward which the composition points (fig. 3).

■ WHEN YOU DISPLAY A SINGLE WORK WITH COMpositional direction you need some sort of counterbalance to return the view to the work at hand. This can be done by placing potted plants on a level with the artwork or by placing a tall piece of furniture beside the artwork. Using a door or window doesn't return the view to the artwork because the viewer will start looking out the window or through the door rather than look at the work of art.

Portraits can offer real problems in effective displays. Fortunately, sitters seem to prefer being represented full-face or nearly full-face so that the finished portrait is essentially in balanced composition. However, a large number of portraits show the sitter in strong profile or with the head turned three-quarters away from the front, away from the viewer. This type of portrait has strong compositional direction and is referred to as a *directional* or a *profile portrait.* When directional portraits are displayed so that they all are turned in the same direction, the viewer will want to see what the subjects are looking at and will turn away from the artworks (fig. 4).

Directional portraits should never be placed back to back

4

Words in boldface can be found in the glossary.

(fig. 5). When this is done, the subjects seem to be incompatible with each other and with the viewer, who will simply ignore them. Such works should be placed facing each other when possible (fig. 6). If

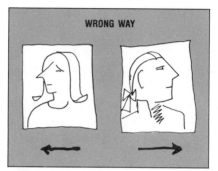

WRONG WAY

Fig. 5

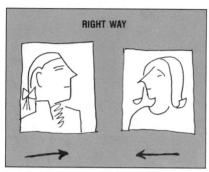

RIGHT WAY

Fig. 6

they were created as an actual pair, they may be positioned closer together. If not a pair or if even from different cultures or times, a wider space should be used between the works.

If you want to be creative, you can make exciting displays using works with weak or strong compositional direction counterbalanced by works with balanced composition or even with works that have compositional direction in reverse (such as arrows pointing at each other). Such a display usually looks best if you use a balanced compositional work between two works of opposing direction. Better yet, if the two outer works are small and run horizontally, place a tall vertical form between them, creating a rhythm that enhances both the art and the viewer's appreciation. The scheme forms a shape that, from prehistory to the present, has been one of the most enduring and psychologically satisfying known to mankind. Any art in such an **arrangement** looks wonderful.

To encourage the viewer to look at the artwork, try a **direction/ counterdirection** balance. This can be aided by using works of similar size to flank a larger or smaller work between them (fig. 7).

When you have several pictures that have the same compositional direction in a line along the wall, there must be a **stopper** at the end or the viewer's glance will slide right by them. The stopper should be a work with a strong **counterdirection,** not just one with a

Fig. 4

Fig. 7

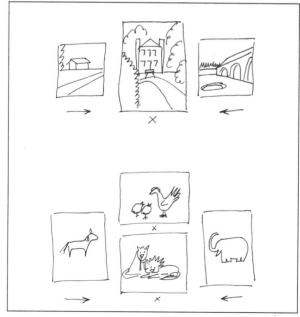

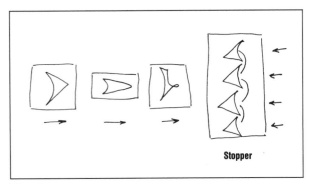

Fig. 8

different direction. An added measure of interest is to have the stopper be a work both larger and at right angles to the line of smaller works. It should also be very emphatic in its counterdirectional flow (fig. 8).

Figure 9 has no adequate stoppers to direct the view inward. Therefore, the arrangement has an outward and upward explosive effect that destroys its cohesion.

Figure 10 creates a circular visual rhythm caused by the **placement** (positioning of) directional compositions working for, rather than against, the design. The balanced compositions are allowed to stabilize the arrangement.

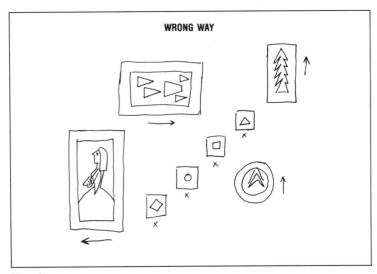

Fig. 9

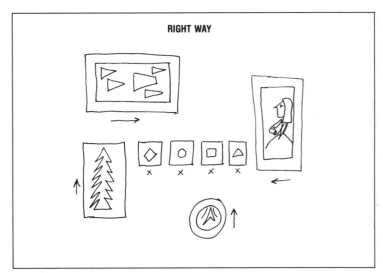

Fig. 10

SUBJECT MATTER

■ **Similarity of subject matter** produces compatibility; dissimilar subject matter is incompatible or, at best, awkward. When you place incompatible subjects together, the viewer tends to look away. It becomes an uncomfortable and unpleasant experience to confront works of highly differing subject matter placed together.

A good display involves works that have some sort of similarity to tie them into the group or placement. By *group* or *placement*,

I mean two or more works arranged to create a pleasing pattern on the wall, tabletop, display case, or wherever you wish. These works may be widely separated, but are on the same wall or in the same general area and therefore are confronted by the viewer more or less as a group.

The similarity of the artworks in a group may be as loosely related as simply those of a figural type. For example, portraits of people can be put with pictures or sculptures of people doing things or with studies of life models. Such similarity could be extended to include parts of human anatomy: hands, feet, etc. Durer's famous and popular *Praying Hands* could be used in such a group. Interestingly, *Praying Hands* does not look at all well with groups that are strongly religious in flavor but do not include any figural work.

IMPACT INTEREST

■ WHEN DESIGNING A GROUP OR PLACEMENT OF DEL-icate **line drawings** — works composed entirely of line work with no shading — where there is relatively little solid, filled-in area, similarity can be stretched to include similarity of medium handling. (**Medium** is the material used by the artist to draw or paint or sculpt his subject matter).

Fine line drawings in ink or pencil can be comfortably placed together, usually without regard to the exact subject matter. However, you should be careful that such a grouping does not become humdrum because of lack of impact interest. To excite the interest of the observer, a group must have **impact interest** — a strong *punch* that draws attention to the art.

A group of line drawings, in ink or in pencil, could be so delicate that a viewer would not be able to see anything inside the framing from a distance of five feet. Such a group would need to be punctuated with something of impact to draw the viewer's attention. If you centered the group with a work with broad areas of ink wash and subject matter related to that which dominated the group, you would have a good example of impact interest. The group could be flanked by attention-getting drawings with **area shading** as opposed to deli-

cate line drawings. This serves to frame the entire group and draw the viewer's attention to the heavier, shaded drawings as well as to the fragile line drawings.

VISUAL WEIGHT

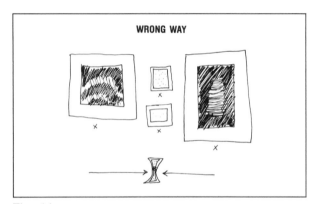

WRONG WAY

Fig. 11

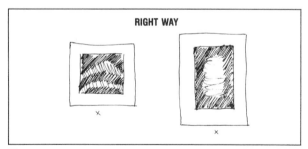

RIGHT WAY

Fig. 12

■ THE DEGREE OF AREA FILLED WITH SOLID OR BRO-ken surface is **visual weight.** Line drawing has relatively little visual weight. The line creates the main form and perhaps delineates the inner shapes of the subject. ***When the artist begins to shade a form or place an outlined form against a solid background, the work takes on visual weight.*** When color is an element of the work, the visual weight increases with the intensity of the colors used.

A work with heavy visual weight can be balanced against a number of works with light visual weight. A brightly colored painting can be used in combination with a number of delicate line drawings or partly shaded drawings; however, the problems that arise are tricky and need a thorough understanding of display techniques to be solved successfully (figs. 11 and 12).

Frequently, even an understanding of these techniques will produce results inappropriate for artworks in a living space. Museums often use this kind of display to produce strong effects. We might be dazzled by the museum's **exhibit** and try to approximate it at home, but the result is usually too strong for the normal living or working space. Even in museums, such showy displays are most often kept only for the temporary exhibition. Permanent **installations** of this nature are too difficult to live with, and they tire the viewer rapidly.

COLOR

■ WE ALL KNOW WHAT COLOR IS. FOR OUR PURPOSES here, because there are so many technical modes of discussing color, I will make things simpler by using the traditional artist's color wheel

(fig. 13). Should you wish one for yourself, you can pick up one of these color wheels at most any art-supply store.

As you can see from the drawing, a **color wheel** is a circle divided into six equal segments. Three of the colors — yellow, red, and blue — are called **primary colors** because the entire range of colors available to the artist is made from mixing together two or more of these three primaries in various proportions.

To assist the artist, there are also three **secondary colors** — orange, green, and purple. Each secondary color is made by mixing together two of the primaries in equal amounts. Green is the combination of blue and yellow; orange is the combination of yellow and red; purple is the combination of red and blue. Another term used by artists is **complementary color.** You will notice on the color wheel that the primary, yellow, is opposite the secondary, purple. They are complementary colors, or colors opposite each other on the color wheel. Therefore, the complement of red is green, and the complement of blue is orange. *Pigment* is the word used for the actual color substance that the artist uses.

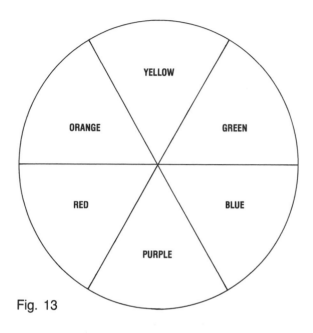

Fig. 13

Before the latter part of the nineteenth century, the artist muted and subdued his colors by the use of white, gray, and black pigments. A surface we see as white is actually a surface repelling all colors. A surface we see as black is actually a surface absorbing all colors. Gray is the combination of white and black.

During the nineteenth century, artists became more and more involved with determining exactly what sunlight did when reflected off a surface. The Impressionists carried this investigation of color as far as they could take it, given the scientific advances of their day. They announced that there was no true black in nature, even in the darkest night, and that pure, full-intensity color should be the basis for all painting. They created gray by mixing complements on the color wheel. Rather than having the deadening effect of black or the fading effect of white, the Impressionists found that gray made from complements was very lively and exciting.

The color studies made by the Impressionists opened the way for twentieth-century artists to use color in a new manner. Much of the color used by modern artists is so strong that displaying their paint-

■ BASIC CONCEPTS

Good grief! It's a black-and-white landscape! Where's all the color gone?

ings has become a problem for the untrained and for the professional. There are many new paintings that dominate anything nearby because of their color. There are a few rules, however, which make it easier to display paintings of this nature.

Many modern artists like to employ brilliant colors in their works. Often a painting will be basically blue (or any of the other primary or secondary colors) with a mixture of less intense, subtler tones. Complements tend to clash or fight with each other when placed side by side. We've all experienced the optical illusion caused by the juxtaposition of, say, pure red and pure green (complements) causing a vibration to the vision. Works of this nature usually cannot be incorporated into any sort of grouping with other colored works.

If you own works of this type, the best way of showing them is to go all out for the **dramatic effect** and place each on a separate wall, opposite each other or, perhaps better, in different rooms. Dramatic effect means to give star-billing to a work of art. However, a strongly colored painting, drawing, or graphic can be used in combination with black-and-white drawings or paintings. Also usable are paintings where the colors are so muted as to effectively be in tones of gray. Still, the brightly colored work will dominate anything near it.

A much more effective way of displaying such a painting is to place it near a fairly large piece of sculpture. Sculpture created in stainless steel, clear or opaque plastics, glass, or shiny high-tech materials seems to hold its own when used near dominating, brilliantly colored paintings. When you design a display, it is necessary to remember that you, your friends, or strangers must be able to confront the display comfortably, or the display is a complete waste of effort.

VISUAL MASS AND SPACING

■ THE APPARENT SOLIDITY OF A WORK OF ART IS ITS **visual mass,** which is created by the color, texture, shading, line work, and brushwork used by the artist. Visual mass can also be the real volume of space occupied by a work of art, as in sculpture.

Varying the size of works used in a display is more interesting

and therefore preferable to having works all the same or nearly the same size. However, there may be a series of works, all the same size with similar or differing subject matter, which we want shown together. A good solution is to align the works in a row or rows with the same measurement of space between each work, thus creating a visual mass of the entire display. In such arrangements, keep in mind the steps already discussed. If the individual items are comparatively large, you need to plan for a rather large wall expanse. It is possible when using a series to take the display around an inside corner of the room, but such a design is tricky and best left to the professionals. If you decide to try this kind of thing, remember that both walls involved will be seen by the viewer as a continuation of the same space and, therefore, as one visual mass. This design produces a dramatic effect.

In the normal manner of arranging one or more works, it should be remembered that larger pictures or sculptures should go on longer walls and smaller ones on shorter walls. A small picture on a large wall looks like the last shrimp on a serving tray; conversely, a large picture on a small wall usually crowds like an elephant in an elevator. A large picture can be used effectively in a small space only if it is treated with dramatic effect with nothing else nearby.

The most exciting way to treat different-sized works in a display is to alternate large and small. One should keep in mind that if a small vertical picture is the same height as a larger horizontal picture, the alternating effect is minimized. ***The rule to remember is that the small picture should be about half to two-thirds the size of the large one, or perhaps that two small pictures equal one large one in surface area.*** A very good arrangement is one in which a larger picture is flanked by two smaller works. The rhythm set in motion by this kind of design delights the viewer and captures her attention. An inner rhythm can also be produced by the balance-counterbalance of compositionally directed works contrasted with compositionally balanced ones. Contrasts can be emphasized by mixing various media. However, in this kind of complicated arrangement, something should be used to tie the display together: similarity of subject matter, color tonality, or perhaps works all by the same artist.

PROTECTING YOUR ART

CHAPTER TWO

Framing
Matting
Acid-Free Paper
Acid-Free Mats
Foxing
Light and Other Hazards
Artificial Light

● PROTECTING YOUR ART

FRAMING

● A PAINTING SHOULD ALWAYS BE FRAMED TO PRO-vide maximum protection from accidental damage or mishandling. Artworks on paper, in addition to being framed, should be shielded by a covering of glass or plexiglass. This is called **glazing.** Normally, oil and acrylic paintings are not glazed, while drawings, watercolors, and **graphics** (original prints) are. This is because the oil and acrylic paintings have been protected with a varnish coat applied by the artist. Works on paper, however, cannot be so treated and must be protected by glazing. The rule is as follows: *if the work is on paper, it should be under glass or plexiglass.*

The type of framing selected for a work should be compatible with, and dependent upon, the work itself, not with the surrounding decoration of a room. If the artwork goes well in a room and the frame goes well with the artwork, then the frame will go well with the room. Some framers, however, see the frame as a highly decorative entity in itself. When an elaborate frame is placed on a subtle picture, the picture is almost totally lost within the complexity of the frame. A simple, uninvolved frame molding, sturdy enough to protect the picture's weight, is the best solution. It can be gilded or silvered, painted or natural wood, or even high-tech metal, but *simplicity is the rule.* An exception to this occurs when the work is from an earlier period in history. Then it is best to obtain a frame from the same time period as the work of art. Generally, these older frames tend to be somewhat fussy, but so is the handling of the subject matter in older pictures. *Period frames look very good on pictures from the same period.* When you are about to have something framed, visit your local art museum and see how a similar work is framed. When a work is framed properly, both frame and picture should present a single, complete entity.

MATTING

● SURELY ALL OF US HAVE TAKEN A PRINT (ORIGINAL graphic), watercolor, or drawing to the framer and have had to decide how wide a margin of paper mat board there should be outside the image of our work of art.

From the early years of this century to the present, a much overused method has been to mat a work with narrower margins at top and sides than at bottom. The history of this is that original graphics (engravings, etchings, lithographs, serigraphs, and wood-block prints) have the title of the work, edition number, and artist's name penciled below and outside the image in the paper margin of the print. Since collectors wanted this information visible, framers compensated for the inch or so of white paper below the image of the subject matter by slightly widening the bottom margin of the mat. Soon, however, watercolors and drawings (which are not so labeled) began to be matted with the same thickening of the bottom margin. This tends to distort the overall unity of the framed work of art by pulling the view downward, away from the picture subject itself. The mat becomes more important than the picture.

The rule for original graphics is as follows: ***Top and side margins should be equal while the bottom margin can be up to an inch wider than the other dimensions.*** The rule for watercolors and drawings is to ***make all four mat margins the same width.*** Your framer can advise you on the exact inch-width of the mat margins so your picture will not be dominated by the mat.

Do you think that maybe the mat margins are a bit wide?

ACID-FREE PAPER

●FOR THE PAST SEVERAL DECADES, MUSEUM CURATORS, collectors, and framers have become increasingly more alert to the benefits of acid-free paper and to the extreme hazards of non-acid-free paper in the matting of artworks. **Acid-free paper** is made from cloth or rags rather than from wood pulp, the substance from which most paper is made.

The humidity in our atmosphere is water (H_2O). Wood pulp is essentially sulfur (S). When water combines with sulfur, you get sulfurous acid (H_2SO_3). All non-acid-free paper emits a microscopic fuming of sulfurous acid. The acid causes non-acid-free paper to become dry and brittle and to turn brown. This effect is called **chemical burning.** Chemical burning also attacks acid-free paper when non-acid-free paper is pressed tightly against acid-free paper, as

when a work of art on acid-free paper is matted with non-acid-free paper. If the condition is allowed to go on unchecked, the work of art on the good paper will be utterly ruined by the bad mat.

Acid-free paper is also called rag board or museum rag board; non-acid-free paper is called **wood-pulp paper** or pulp paperboard. Until quite recently, rag board was commercially available only in a limited number of pale colors plus white. However, now most of the country's largest paper manufacturers are producing rag matting board in a wide range of colors. Rag board is slightly more expensive than pulp paperboard, but your works of art matted with rag board are protected from chemical burn.

ACID-FREE MATS

●IT IS VERY EASY TO DETERMINE WHETHER THE MATS used on already framed pictures are made of acid-free paper. All mat board is made the same in its manner of building up the thickness plies. The top, or color, layer is placed above a series of whitish sheets of paper; the entire pile of paper is then laminated to form a stiff paperboard. The under sheets of wood-pulp board tend to be slightly yellowish while those of rag board are pure white. When the framer cuts out the beveled mat window, the thickness of the paper ply shows. If the color of that ply is pure white and stays pure white, the mat is made of acid-free paper. If, on the other hand, the ply is slightly off-white and begins to darken with the passage of only a few months, the mat is made of wood-pulp board. If the mat bevel is covered, it would be necessary to remove the backing paper (which should also be acid-free) and examine the cut outer edge of the mat hidden by the frame. The backing board behind the artwork should also be acid-free or damage will result.

Another indicator of non-acid-free paper present in an already framed picture is the telltale sign of a brownish darkening adjacent to, and parallel with, the inner edge of the mat window. The damage under the mat will be severe by the time this darkening begins to creep out across the picture image.

● A PHENOMENON RELATED IN APPEARANCE TO chemical burn is **foxing.** It occurs when small, light brown spots appear on the surface of the paper. These spots seem always to appear in the worst possible places — the middle of the sky, on the end of the sitter's nose — everywhere, in fact, that is objectionable. Although artists try to use the very best acid-free paper for their art, occasionally even the best is not quite good enough. Foxing marks are actually rust stains resulting from iron particles embedded in the paper during its manufacture. Repair of the damage from foxing is a job for the professional conservator. The conservator can also repair chemical-burn damage.

FOXING

● A HAZARD THAT STRONGLY AFFECTS ARTWORK IS the exposure to **ultraviolet light.** Ultraviolet (UV) light is what makes plants grow, gives us our summer suntans, or bleaches color and

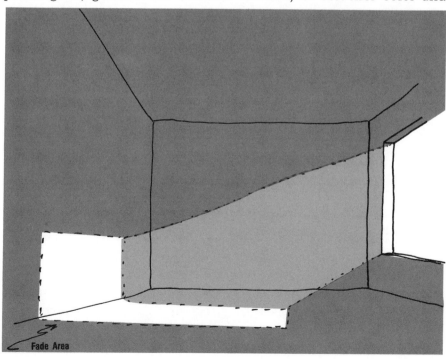

LIGHT AND OTHER HAZARDS

Fade Area

PROTECTING YOUR ART

photochemically burns works on paper. The effect on paper is similar to acid burn, but instead of occurring around the edges near the mat window, UV burn dulls the entire exposed surface of mat and image. A new solution to this problem is the use of either glass or plexiglass that has been treated to effectively filter out about 97 percent of the UV light. Your framer will have access to this kind of glazing material.

Other hazards for original works on paper are direct sunlight, which rapidly bleaches the work; paper-eating pests such as silverfish or cockroaches; too high a humidity, which can produce mold that destroys the work; or too low a humidity, which causes the surface to shrink, possibly tearing the paper, when the temperature is too high — a condition of winter heating. Although it is uncomfortable for home use, museums try to maintain a humidity range of 35 to 55 percent with a temperature range of 68 to 72 degrees Fahrenheit for the safety of their art collections.

ARTIFICIAL LIGHT

YOU SHOULD KNOW THE EFFECTS OF ARTIFICIAL light on all art, especially works on paper. Fluorescent light tubes are often used to assist the proper growing of houseplants when sunlight is not sufficient. Fluorescent tubes produce large amounts of ultra-violet radiation. An unfiltered fluorescent tube can be more harmful than direct or indirect sunlight because natural light is variable and fluorescent light is constant while turned on, particularly in office environments. Lighting engineers, recognizing potential problems to artwork produced by fluorescent light, have devised a plastic filtering sleeve that effectively screens out approximately 97 percent of the UV radiation produced by a fluorescent tube. According to lighting experts, the sleeves last indefinitely, and they do not lose their effectiveness. It was the availability of this plastic that led to the invention of UV-free plastic and glass sheets to cover entire pictures.

In addition to fluorescent lighting, ordinary incandescent light bulbs can produce a bleaching effect on artwork. Coupled with bleaching are hazards of extreme drying and, on occasion, physical burning when the bulb gets too close. Pictures should not be hung

over lamps where the full flood of illumination falls directly on the picture. Many people use 100-watt bulbs, or higher, for table or floor lamps in interior lighting. It has been discovered that an unshaded 100-watt lamp placed less than ten feet from an artwork will do considerable damage, fading or dulling the brightest colors within a year's time. Such light is much more destructive on fabrics, especially tapestries and oriental rugs. The reds, pinks, yellows, and light blues used to dye threads are particularly prone to fading in strong light. You've probably seen antique tapestries where the dark greens and blues are very apparent, but, for the most part, the rest of the work is dull gray or buff. This effect is caused by a combination of sunlight and artificial light. Few tapestries more than 150 years old retain much of their original brilliant coloring.

Of all the hazards from artificial lighting, intense spotlighting (or floodlighting) is one of the worst. Because a spotlight or floodlight bulb is small, we tend to forget what a strong concentration of light the bulb projects onto a relatively small surface. Many persons using this lighting in their homes normally over-light surfaces, and the greater the light concentration, the greater the fading. Most of us have experienced the annoyance caused by moving a picture that has been hanging in one spot for a long time and discovering that the wall beneath is darker than the surrounding area. Light has bleached the wall, including the picture, so that when we remove the picture, we see the original wall color which was screened by the picture. When spotlights or floodlights have been used as the major source of lighting, the bleaching effect can be drastic. The remedy is to *lower the wattage and place the light source at least ten to fifteen feet from the art object.*

A good way to provide even, low-intensity lighting for your artwork is to create indirect lighting. Indirect lighting consists of bouncing direct light off an intermediate surface onto the artwork. The traditional reason for painting ceilings white or off-white is that lamplight reflects off the ceiling to produce an even, indirect light that does not fade the furniture and fabrics in the room. If you do use spotlights or floodlights, use no more than 50- to 60-watt bulbs and keep the source light about ten feet from the object. Most museums

● PROTECTING YOUR ART

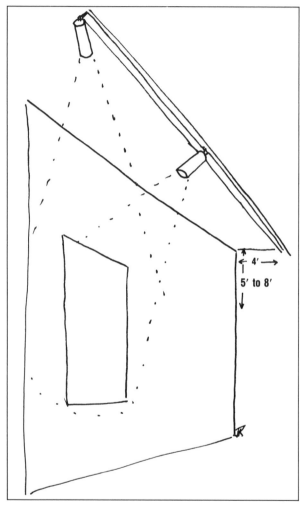

To fully illuminate a picture, use floodlights attached to a track light rail. The rail should be placed at least four feet out from the wall, flush with the ceiling. The floodlights should be placed just beyond the outer vertical edge of the picture and turned so the light will rake across the surface.

4'

5' to 8'

using this type of lighting find that spotlights are too damaging, so they use only floodlights.

Illumination is measured in **footcandles** by lighting engineers. Many standard photographic light meters register in footcandles. To minimize the hazards of lighting bleach, remember that ***woven fabrics (tapestries, rugs, and antique or modern upholstery, for example) should be lit by no more than ten footcandles; works on paper should be lit by no more than twenty-five footcandles; paintings should be lit by no more than forty-five to fifty footcandles.*** Direct sunlight at a thirty-degree angle above the horizon (early morning or late afternoon) produces about 800 footcandles of illumination when shining into a room. Indirect sunlight at noon can register between 200 and 750 footcandles, depending on the amount of exterior shading produced by vegetation.

Picture lights (those small, tubular-shaped bulbs that fit into a coved, inverted trough usually fastened from the back side of the frame and suspended out over the top center of the picture) can be another source of light hazard. If the owner leaves the picture light on continuously, there will be strong bleaching and equally strong drying in the upper center of the picture, even if the bulb is as low as 25 watts (the usual strength for these bulbs). If the bulb is stronger, the damage will be consistently greater. I use picture lights on several of my oil paintings. However, I use them only on an average of one or two hours a week, and even then I am concerned about the bleaching and drying damage that is occurring. ***If you use picture lights, use them sparingly, with no greater than a total of 25-watts illumination.***

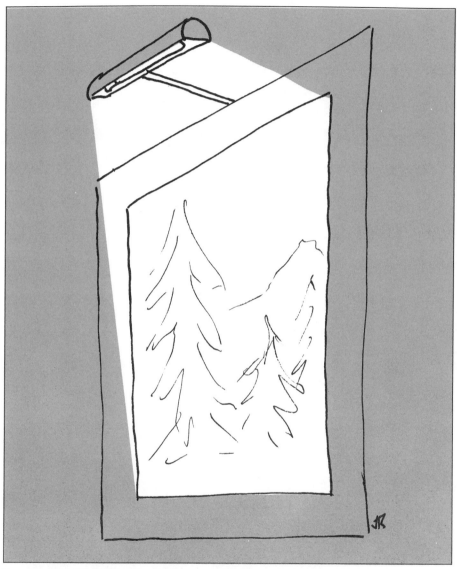

If you have to use picture lights, make sure they are positioned so the fixture is as far as possible from the picture surface and the bulb is no more than twenty-five watts. This will minimize damage from heat and reduce the hazard of fading from an artificial light source so close to the work. Use the light only occasionally.

WHERE TO PUT WHAT

CHAPTER THREE

No, that's not one of Picasso's models . . . she's just been looking at too much art above her eye level.

WHERE TO PUT WHAT

❖ So far I have discussed, in chapter 1, compositional direction and its influence on display, subject matter, impact interest, visual weight, color, visual mass, and wall spacing. Chapter 2 covered framing, mounting, and hazards caused by improper materials and lighting problems. Now it is time to examine the actual manner of designing an effective arrangement.

EYE LEVEL AND CENTERLINE

❖ The most universally pleasing way of showing off a work of art is to position the **centerline** of the picture on, or close to, the approximate **eye level** of the viewer. I'm speaking of the horizontal centerline, which occurs exactly halfway between the top and bottom of the frame.

Remember that eye level changes as much as eighteen inches to two feet when people sit down. If the art is displayed in the living room, dining room, or bedroom, most people (you, for instance) will probably be sitting down most of the time in the room. If you place wall-hung art so that it looks well while people are standing — in a room where most of the people stay the longest in a sitting position — the viewer will completely ignore the art. It is above his eye level, and he won't strain to look at it.

This, by the way, is the major cause of that peculiar phenomenon well-known to gallery or museum visitors as **museum fatigue.** If the art is placed so that you have to strain the back of your neck, arching your back and stretching your legs so that, in effect, your profile resembles a bent bow, you will surely get museum fatigue. Standing in this most unnatural way tires you quickly. To a lesser degree, this occurs while sitting. The chief difference is that while sitting, the main stress is on the back of the neck. If you and most of your friends wear bifocal glasses, this should be kept in mind, and the eye-level centerline should be lowered so you don't have to crick your neck to look at the art. ***Art should be placed at a level where it is comfortable to see.***

The Dutch, who are particularly adroit at museum installation, have displayed their national collection of European and American

Fig. 14

contemporary art so that the bottoms of the biggest pictures just miss the floor by a few inches — in galleries with twenty-five-foot ceilings. The art is easy to see and to enjoy, and few people avail themselves of the benches considerately placed in each room. You can stand comfortably in front of a work without the need for rest or for relaxing strained muscles.

In those rooms of your home or office where people normally stand or pass through, the eye level should be higher than in a room where people are normally seated. To determine an **average eye level,** you can measure or estimate the relative view level of the tallest and shortest adult members of the family or group. The average level is halfway between the two extremes (fig. 14). Most people are satisfied with this average, although it is easier for a tall person to lean forward to view something than it is for a short person to lean backward. In the children's room, art should be placed to suit their eye level rather than an adult's.

Arranging wall pieces on an eye-level centerline means that the middle of the vertical (height) dimension of the work is on eye level (fig. 15). In a normal sitting-room situation, the centerline should be slightly higher, since people tend to lean back, raising their view direction higher than actual eye level. This insures that the bottoms of pictures are high enough above sofas and chairs so that the heads of sitters will not rub against the pictures or frames. Aside from being hard on the pictures, it is extremely annoying to the person sitting below to have to duck away from art overhead.

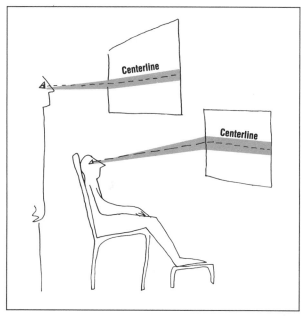

Fig. 15

❖ ANOTHER SYSTEM OF ARRANGEMENT IN WHICH ALL framed works are placed in a group with the bottom edges of the frames in a line, flush with each other, is **flush-edge placement.** In my opinion, this looks a bit contrived except in rare instances. The art seems to be subservient to any furniture or floor levels below it, and flush edge works only if the pictures are all approximately the same size. It looks ridiculous if some of the framed items are as much as twice as tall as the shorter ones. The same holds true for flush-top

FLUSH EDGE

25

line, except that the pieces seem to hang from an invisible cord, like laundry on a clothesline. By using the centerline method, each individual work of art is treated separately and is not forced to adhere to an arbitrary rule.

Be aware of the exact level of the horizon line within the subject matter. The horizon, or main line of interest (such as the horizon line in a landscape), which is a horizontal line, can prove troublesome if not taken into consideration. For example, visual discomfort results if pictures with greatly differing horizon lines are placed side by side (fig. 16).

Fig. 16

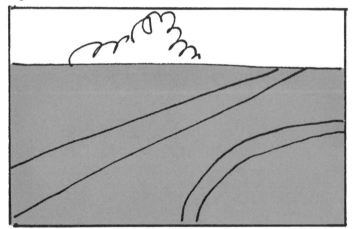

The problem is usually insolvable for most viewers, so they simply won't look at the pictures. If you hung these works in the manner illustrated in figure 16, you'd soon want to get rid of them. The problem, however, is not in the pictures themselves, but in the hanging arrangement.

Some people might try to line up the horizon lines, but to do so would probably look confusing and contrived. That certainly is no solution (fig. 17).

The two examples shown here could be hung one above the other, with the low-horizon-line picture above and the high-horizon-line picture below (fig. 18). A low horizon line means we are looking upward at the subject, and a high horizon line means we are looking

26

Fig. 17

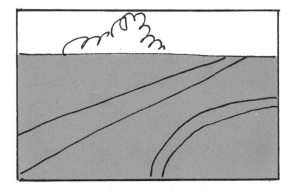

down on it. This is not the best solution, but it would allow the viewer to see the works separately and distinctly.

It is uncomfortable to see these two subjects with the down-looking scene above and the up-looking scene below (fig. 19). Such an arrangement reverses natural order and serves to confuse the viewer. Visual confusion is uncomfortable, and the viewer simply won't look at such an arrangement.

The best solution would be to hang these two works on separate walls or, better yet, with a sculpture or plant between them.

The artist uses the horizon line as a means of establishing **visual depth** and scale to a landscape or seascape. For instance, if you placed a small picture that showed great **depth of field** (visual depth) next to a still life with objects shown on a table, the result would be to imply that the objects of the still life were the same size as the objects in the landscape, and the tabletop was as great in depth as the implied depth of the landscape.

One of the most amusing mishaps in combining works of dissimilar subject matter occurred in a major museum that was showing a large group of nineteenth-century American works. The curator who designed the installation attempted to recreate the effect of clutter apparently so admired by the Victorians. Among the many

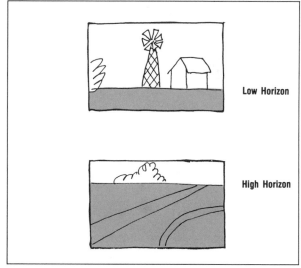

Low Horizon

High Horizon

Fig. 18

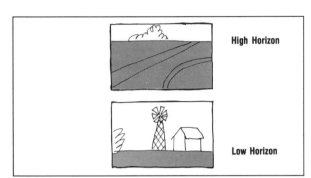

High Horizon

Low Horizon

Fig. 19

well-positioned works, he inadvertently placed a tall, vertical water-color of the Upper Yellowstone Falls (seen from below) above a large, horizontal-format still life that included a wide, shallow bowl. The bowl seemed to be waiting to receive the gigantic flow of water from the painting above. Both paintings, by leading artists, were stunning examples of their type. However, on the opening night of the exhibition, a crowd gathered in front of the pair, not to admire their quality, but to laugh at the incongruous effect. The two works were placed in different positions the next day.

GROUP ARRANGEMENTS

❖ MANY PEOPLE SEEM TO PLACE PICTURES IN bunches when perhaps one would be sufficient. These persons discover that they have too many works for a given wall space, and they hang the pictures as a group. A group occurs when the person designing the display wants the pictures seen as a visual mass. In other words, the group becomes a decorative entity. ***The quality in a group is determined by the interrelation between individual works.*** If there is good interrelation between the various pieces, the group is a success. Interrelationships can be obtained in an almost infinite number of ways. Most of the points discussed so far bear on the successful solution of the group: balanced composition, compositional direction/counterdirection, centerline, eye level, horizon line, similarity of subject matter, and balance of visual masses.

DESIGNING A GROUP ARRANGEMENT

❖ IN DESIGNING A GROUP ARRANGEMENT, THE EASI-est method is to find a floor space comparable in width and length to the width and height of the wall to be used. Then, lay the objects and pictures out on the floor in the desired pattern. When this is done to satisfaction, make a drawing of the entire arrangement, getting measurements of the spaces between each work. Then hang the works on the wall in like manner.

DISPLAY INTENT

❖ ANOTHER POINT TO CONSIDER IS THE INTENT OF your display. **Display intent** is what you want the display to do for you. If you want the display to look clumsy, it can be done easily by violating the rules discussed so far. If you want humor, you can mix subject matter; if you want machinelike rigidity, you can use the flush-edge placement; but if you want subtlety and you are concerned about getting the individual items seen, follow the basic steps as introduced in chapter 1, and below.

FIND THE GROUP CENTERLINE

❖ THE FIRST THING TO ESTABLISH IN HANGING A group is the centerline of the visual mass. Second, find works with similar or related subject matter. Third, find the biggest picture or object with balanced composition and place it in the middle, properly on the centerline.

For the fourth step, select two more large pictures, either larger or smaller than the middle one, but preferably not the same size. These two pictures should involve compositional direction/counter-direction, but they can also be of balanced composition. The pictures should be placed at either end of the group, centered on the centerline.

Then, depending on how much wall space remains, begin to fill in, first one side, then the other. You might compare this part to making an attractive and tasty sandwich — you have the two pieces of bread on either side and the meat in the middle. On one side of the meat, you might have pickles and mustard and, on the other side, tomatoes and lettuce. Your art objects should be balanced in some way, basically in overall size. Two small works can equal one larger work if their combined areas, plus the space between them, equal that of the larger work. Using this variation, you can keep the arrangement from becoming static or rigidly symmetrical.

The simplest grouping is comprised of three works. A more complex grouping would be five, seven, or nine works, and so forth. To give impact interest, if the grouping gets rather large or starts

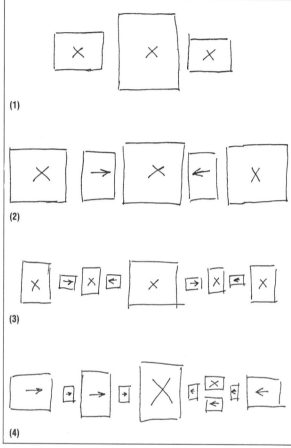

Fig. 20

looking static, try a double hanging at one place to balance a single work on the other end of the group.

The sample arrangements shown in figure 20 give a visual realization of sizes, eye level centerline, and overall wall rhythm. These tend to be **formal arrangements.** Number 4, however, with its use of two small objects to equal one larger one and to balance with the other side, becomes a bit lighter and less formal. ***The key here is that slighter or greater asymmetry creates less formality.*** Note that the centerline passes between the two small pictures that are double hung.

Little has been said about intention of display. For most people, the main reason to display a work of art is to enjoy it themselves, have it seen and enjoyed by others, or to fill an otherwise empty corner of a room. There are those who have more specific interests in displaying art. For the collector, a proper, usually single-placement display allows him to examine deeply any aspect of his holdings; for the person concerned with interiors being as attractive as possible without obtaining the services of an interior designer, well-conceived group arrangements interspersed with single works offer great satisfaction.

Throughout the preceding section, comments have been made to the effect that one type of display is more formal than another, and the methods of achieving these different ends are given. Formality or informality in displays helps set the mood of any interior.

To review, the use of gold or silver moldings for frames (preferably as plain as possible so you can see the work of art without the frame dominating) immediately induces a sense of formality. Along with these metallic finishes, a treatment such as the plastic box can be used to produce formality. Frames in painted or natural-finish wood are usually less impressive and so introduce a note of lesser formality. Group arrangements, other than grid patterns, tend to be more informal. Dramatic effect almost always produces a highly formal impact on the viewer and to the room in which the work is placed. Grid-pattern groupings tend to produce formality, but may seem less formal, depending on the type of subject matter and the kind of frame molding used.

❖TO UNDERSTAND HOW THE EFFECT OF A DISPLAY can create a specific mood, you can learn much from commercial interior designers. For example, in fast-food restaurants, where rapid turnover of customers means increased income, the walls are often painted in bright reds or yellows with contrasting colors that are not particularly compatible. Visual material is neatly, rigidly, mechanically arranged, usually spaced just far enough apart so you cannot call it a group arrangement and too close to cause dramatic effect. If you analyze this interior, you will discover that it is really rather unpleasant — certainly not restful or conducive to lingering. That is exactly what the designer has intended and has created. Conversely, in moderately expensive restaurants — where lingering, perhaps to order more wine, is considered essential by the management — colors will be dark, muted, and soft. Visual art is usually present in abundance, arranged in intimate groupings that create a semi-informal effect. In the very expensive restaurants — where the management doesn't expect even a single turnover but encourages the evening's first customers to linger (dinner for two might run around $500!) — the interiors are exquisitely planned with light wall colors, rich luminous upholstery, and good art placed sparingly about the room, punctuating vistas most dramatically.

In office interiors such as banks, law offices, or doctors' waiting rooms, where confidence in service is essential, art is used sparingly, usually singly for dramatic impact or in groups of two or three for formal effect. If, in such an office, you find yourself becoming uneasy while waiting for service, look around you. You will find there is either no artwork used to relieve the interior walls or too many poor examples are carelessly scattered about, producing **visual clutter.**

One of the biggest misunderstandings regarding the presentation of artwork occurs most often in the small art gallery salesroom/ frame shop. Usually the owner attempts to offer as many samples of his wares as possible and overloads the wall space so that virtually nothing is visible as a separate entity. Such stores rarely have return customers (unless prices are drastically below average), and many of those customers will complain bitterly about shoddy workmanship, even if such does not apply. These people are disturbed by the visual

pollution about them. The art gallery/frame shops that seem to make the most money and have the greatest number of satisfied customers are those that display framed works carefully, without the clutter effect. An adage applies here: "Expectation is greater than realization." Those customers who didn't see everything the first visit will probably come back to look more carefully again.

DOUBLE HANGING

Bifocals can be confusing if pictures aren't shown correctly.

❖ WHEN TWO PICTURES ARE PLACED ONE ABOVE THE other, you have **double hanging.** As you have seen, one set of double-hung works can nicely balance a single work which has an overall area approximating the area of two smaller works. In this case, the larger work should be vertical to balance the visual effect of the double-hung works. When using double hanging, make sure that the overall vertical space allotment does not crowd the top or the bottom.

For a slightly informal effect, a pair of similar-sized works can be double-hung above one end of a cabinet or chest, visually balancing a tall lamp placed at the other end of the chest. In this simple arrangement, formality or informality is controlled by the nature of the objects used. It is advisable to keep the double-hung pictures smaller than the total height of the lamp, but in doing so, the overall assemblage (chest, lamp, double-hung pictures) creates a compositional direction toward the side on which the double-hung pictures are placed, since they do not take up as much visual mass as the lamp.

To keep compositional balance for such a group, the top level of the upper picture should be level with the top of the lamp. You must take care that the lamp does not cast any direct light on the pictures or there will be light bleaching. If you do not care about the damaging effect of light bleach, then make sure that any direct flow of light does not make a line across one or the other of the pictures (where part of the artwork receives indirect light and part direct light). This is an uncomfortable visual effect, and the viewer will not look at the arrangement.

MULTIPLE HANGING

❖ WHEN YOU PLACE THREE OR MORE WORKS IN A vertical stack, you have a **multiple hanging,** which is also used to indicate three or more works placed in an arrangement intended to be seen as a single entity. Multiple hanging is a good system to create an intimate informality. This system can present a pleasant cluster if composed of a variety of types of artworks. In this case, similarity of subject matter can be almost completely disregarded. If, however, you want a more formal result, keep the subject matter similar. Multiple-hanging groups were once used to give interest to the long expanse of wall above a sofa. Although this is not particularly fashionable anymore, multiple-hanging groups can provide pleasure, entertainment, and interest to owner and viewer alike, in just about any location in your environment.

MULTIPLE-HANGING RULE

❖ *THE RULE TO FOLLOW IN DESIGNING A MULTIPLE-hanging group is to determine which item or items you wish to emphasize.* By combining several of the group-arrangement patterns, by keeping the entire arrangement outline roughly oval, circular, square, or rectangular with the items of chief interest in or near the center, and by using as great a variety between adjacent works as possible, you can create a marvelously entertaining, clustered effect.

Centuries ago, long before the first museums were dreamed of, noblemen and wealthy collectors created what have since been called *curiosity cabinets.* These were often whole rooms filled to overflowing with such diverse objects as fine, miniature paintings, small sculptures, unusual or rare pieces from various contemporary or earlier cultures, items of natural history such as dinosaur bones (thought to be bones of giants and dragons), rhinoceros horns or spears from swordfish and narwhals (all thought to be unicorn horns), and similar peculiar objects. You can certainly see why these small rooms were called curiosity cabinets.

These rooms were the ancestors of the **cluster arrangement,** multiple-hanging groups. As you can see, almost anything is permissible in such an arrangement. When such a group is formalized, it

You don't think you crowded the corner a little bit, do you?

looks contrived, artificial, and static. It's the kind of thing you can play with and keep very informal. But do remember such things as compositional balance and direction. ***If you want to break these basic rules, be sure you break them so obviously that anyone looking at the results knows you did it on purpose.***

Depending on the placement and effect you intend with such an exhibit of diverse objects, you can achieve virtually any result. One spectacular such display — used in a basement game room and intended to lighten an otherwise dark and uninviting space — included discarded street and highway directional signs (one-way notices, speed limits, stop signs, and street-name signs), commercial reproductions of transportation subjects, cartoons on travel humor, brochures on exotic travel vacations, antique steamship-line posters, and modern plates decorated with vintage automobiles. The wall was lit by several reproduction carriage lamps. The arrangement covered an entire long wall of the room. The owners and their friends (most of whom had contributed to the collection) called it the "travel room," and everyone seemed to enjoy it immensely. Such a collection obviously included material of a similar subject matter but of a widely diverse variety.

This collection is an example of the use of similar subject matter and effective use of multiple hanging. The only attempt to give the display a professional air was done through excellent framing of those items that had to be framed, and the framing was done by the owners, using ready-made or secondhand frames. With the exception of the travel posters, none of the material was irreplaceable, and so no particular preventative care was taken to guard against light bleach, lack of climate control, or other problems that so quickly deteriorate original art.

GRID PATTERNS

❖ THE TRAVEL ROOM EXAMPLE NOTED ABOVE WAS created through a sort of haphazard, happy-go-lucky placement done as a group effort. That it was so highly effective was because most of the people involved used their innate design sense to the fullest,

because the owners made the final decision, and because they made a basic skeletal plan.

Such a large scheme might have been improved or might have been utterly ruined by the rigid, involved complexity of a tightly controlled interrelated **grid pattern**. A successful grid pattern looks carefree and almost happily accidental. However, all horizontal and vertical lines of frame, mat edge, and even main elements of the subject matters' compositions are carefully taken into consideration and made to interact one with another. Such a design cannot be easily put together, and once together, cannot be altered in one part without upsetting the entire effect.

When successful, the grid pattern is the most exciting, attention-capturing technique of all possible wall-display methods. In large museum temporary exhibitions, the installation designer very often uses this technique, because it not only enables him to display more pictures in a given space, with each one receiving individualized emphasis, but it is so eye-catching and appealing that a visitor unconsciously is drawn to it. A good designer will use the grid pattern sparingly, saving it, perhaps, for the exhibit's most important, smaller works.

Frequently, a good interior designer will use the grid pattern technique in a living environment. Such designers may incorporate the actual furniture of the room into the grid system. Though dazzling in its effect, it precludes ever moving the furniture from the position devised by the designer because the entire effort would collapse. If you have heard someone who has had an expensive interior designer plan his home say, when a new piece of artwork has been acquired, "I'll get my designer to place this," that person probably has an entire house designed on the grid system. One of the great drawbacks to using the grid system is that living (and moving) persons in such interiors tend to upset the perfection of the grid pattern. You might feel that such interiors are like furniture store-window displays, which are complete without people animating the scene.

The multiple-hanging technique is the basis for the grid pattern. Unlike the almost haphazard approach you might use in plain multi-

ple hanging, the grid requires you to measure carefully (by sight or by actual measurement) the overall area of each work; maintain and balance distances between two or more works; align frame edges and mat-window openings on horizontal, vertical, and directional flows; and match such with strong horizontal, vertical, and diagonal lines within each and every composition of each work in the entire display. The reason a grid pattern is so effective is that each frame edge, mat width, and **negative space** between works is like an arrow directing the viewer's attention straight into a specific picture. You can understand how complex this becomes when you add the element of color.

If you wish to try a grid pattern, start with an odd number of line or area drawings, matted with white mats, and framed with plain wood-colored or metallic frames. Select works that have fairly strong or obvious compositional direction within them. Then, using one of the simpler groupings suggested at the beginning of this chapter, lay the works out on the floor beneath the wall where you wish to hang them. Make your exact arrangement, lining up all horizontals, verticals, and diagonals to interlock with the main compositional flows within the pictures' subject matters.

Sounds complicated? Of course. It is very complicated. Sounds contrived? Certainly, it is highly artificial. That is the nature of grid patterning, but the finished result, if carefully and successfully handled, is well worth the trouble. Even if you don't at first master this technique, you will become aware of the fine art of showing art much sooner, and if you keep at it, you will see how soon you can easily contrive one of these grid patterns.

Figure 21 illustrates the example just suggested. In this case, the two outermost works (Bs) have compositional direction; the other works have balanced compositions. The name *grid pattern* comes from the idea that in the simplest method of laying out one of these designs, you could use grid paper (graph paper) and, being completely arbitrary, make your design, then find various works of art to fit the design. This, however, might not be so easy — finding the exact sizes, compositional types, and frame types. Because of using an interlocking design, the grid pattern tends to be more formal.

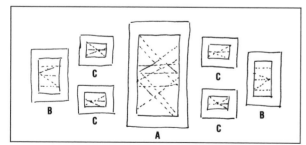

Fig. 21

DRAMATIC EFFECT

❖ ALTHOUGH THE GRID PATTERN FASCINATES AND delights the viewer, it is not particularly dramatic because it is subtle. The viewer becomes entangled in examining each work in detail, and although she takes the time to look at each work so carefully, her peripheral vision allows her to be aware of the surrounding works. These may be somewhat distracting if the works are placed extremely close to each other. ***Dramatic effect cannot occur if there are any distractions.*** A single reproduction of the *Mona Lisa*, placed within the context of a reproduction sales gallery where all sorts of other pictures are seen close by, loses almost all impact. Even in the Louvre's Long Gallery, the *Mona Lisa* almost seems insignificant when shown as just another masterpiece in a museum filled with masterpieces. How dramatic it was on display in Washington's National Gallery — placed against velvet curtains, on a stage like the star it is, with special lighting and armed guards. That's drama!

Dramatic effect is obtained by placing a work entirely by itself on a major wall within a room. Attention can easily focus on it because there is no interference or distraction from any other elements. One point to remember is that if you do place a work in such an exclusive position, it should be of good quality because anything so emphasized will draw immediate attention.

Many people place a major work above a fireplace, forgetting that the usual fireplace is a dark, negative space much of the time and, in format and size, often duplicates the positive space of the picture (or sculpture) above. Dramatic impact is not very great in this placement. The safety of a good work is in danger when placed above a working fireplace because of the hazards of heat and drying, and a gas fireplace can cause chemical reactions with organic paints.

A single work of art can retain dramatic effect if you place it above a low upholstered sofa, as long as the fabric, pattern, and color are very muted, or if you place it above a cabinet or chest of plain design. If you display a good piece of antique furniture beneath a painting or other work of art that you wish to have dramatic effect, the impact will be minimized because of the distraction of the second piece. Most people's peripheral vision extends about eight feet to either side of what they focus their attention on (from a distance of

I don't think you have to be as careful as all that . . . we're not putting anything else in here.

37

five feet). If you have a very long wall and can display works at intervals of about fifteen feet, you can still give them a fairly good dramatic effect. The use of heavy, carved, and gilded frames does not create dramatic impact. Such might even interfere with the art, if the frame is unsuitable for the picture. Again, dramatic effect is achieved by exclusiveness, not by ornamentation or pretentiousness.

SHELF DISPLAY

❖ So far, nothing has been specifically said about three-dimensional objects that are usually displayed on a shelf in a glazed or unglazed cabinet or in a tabletop recess. Many of the points discussed so far can be applied here. A wall-cabinet display should be viewed, for best effect, from directly in front. On one or more shelves, you can create fascinating displays, keeping in mind such points as compositional balance, compositional direction, and visual weight, as well as visual mass, composition flow lines, color, texture, **surface reflectivity,** and size.

Display cabinets, when glazed, are often termed **vitrine cabinets** (*vitrine* is derived from the French word for *glass)*. When unglazed, they may be called *étagères (étage* is the French word meaning *floor* or *level)*. We use the French words because the French apparently were the first to use such cabinets for display of small objets d'art. When **vitrine** is used without the word *cabinet*, it describes a bottomless glass box placed over a single piece of great fragility. The Victorians used a glass dome for this purpose.

When making a display on a shelf, there are two basic systems to use, creating the right effect every time. The first system directs your attention to the center of the shelf (fig. 22); the second system directs your attention to the outer edges (fig. 23). If you have two or more shelves to fill, it would be interesting and more inventive to use the two systems alternately.

The simplest display is to select the largest or most important piece and place it in the center (for safety's sake) about midway between the front and back of the shelf. Then find two smaller objects and flank the center one. Then use two more, slightly larger

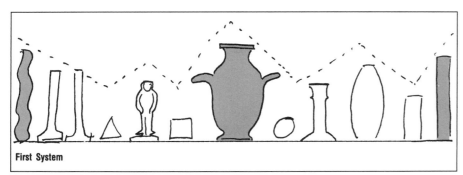

First System

Fig. 22

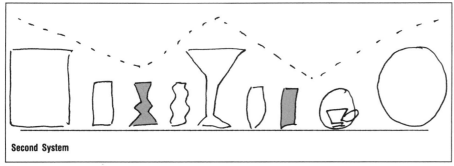

Second System

Fig. 23

but not as large as the center one, and flank the existing three. This method of using varied heights alternately is continued until the shelf is filled. It doesn't matter whether you finish off the outer ends with larger or smaller sizes.

If any of the objects are in pairs or sets, they should be displayed together rather than in flanking positions, simply to lessen confusion. However, a small pair will probably equal the visual mass of a slightly larger single object and can, therefore, be balanced in that way. Variety of objects and types adds spice to this kind of arrangement. This system directs attention to the center of the shelf.

The second system directs attention to the outer edges. Find two objects of approximately the same size or visual mass and place them at the extreme outer edges at each end of the shelf. Then select a number of pieces that vary only slightly in height and visual mass and are considerably shorter or smaller than the end pieces (not less than half as high but not more than two-thirds as high is a good rule to

39

Fig. 24

follow). This group can be used to fill the entire space between the two end pieces, or you can use another larger object to punctuate the center.

In any shelf display, the objects should be placed far enough apart so that they don't create clutter (fig. 24), but they must be close enough together so they don't seem lost on the shelf. If you display a decorative cup and saucer, put the cup to the front and stand the saucer upright in a small plate stand behind the cup. The cup's handle looks best turned away from the center of the shelf, unless the design is hidden by doing so. If you have a series or set of decorative plates or other identically sized but differently decorated pieces, they look good evenly spaced across the entire width of the shelf (fig. 25). If

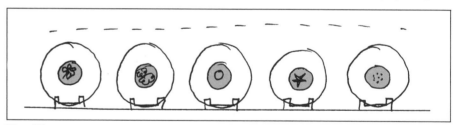
Fig. 25

you were to use such a line, you shouldn't try to vary it, and certainly don't push one plate back and the next forward. This creates confusion and clutter. The two main causes of undesirable clutter are arbitrary variations that are not repeated elsewhere on the same shelf and overlapping one piece in front of another (except in the above-mentioned cup and saucer).

Figures 23-25 show the two main systems in drawn examples with some additional variables. The dotted lines indicate visual

rhythm created by peripheral vision's tendency to mass or group individual items into single multiple-formed entities.

❖ OBJECTS IN A GLASS-COVERED SUNKEN TOP OF A low table constitute a **tabletop display.** The items most suitable for this kind of table are those that look best when seen from directly above — open books, decorative plates, miniature paintings, jewelry (especially necklaces or pendants), elaborate bookbindings, geological specimens, and anything small that looks best when lying flat.

The system to use is closely related to wall-hung groups. It is important to have a subtle or mute-colored backing under the display, but the fabric or other material can be very rich, such as brocaded cloth or velvet. The effect is, after all, that of a treasure chest. Treat it accordingly.

If the area is fairly small, not more than one foot square, you would probably want the most important item in the center; if the area is larger, you might put two important items midway to right and to left, or use two objects in the center. If you are using geological or mineral specimens (uncut gemstones, for example), you may wish to grade them outward in size and quality, large to small, in a sunburst pattern. Seashells are often shown in such tables, and they look good in a circular spiral, leading to the center. The main thing is to make

TABLETOP DISPLAY

Fig. 26

the design look easy and natural, not artificial and contrived. Several suggested patterns are shown in figure 26.

DYNAMIC SYMMETRY

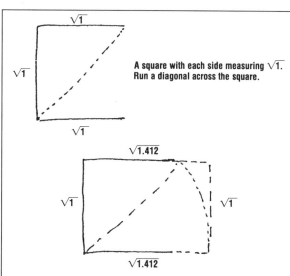

A square with each side measuring √1̄. Run a diagonal across the square.

Rotate the diagonal as if it was the radius of a circle until it is even with the base line of the square. Then extend the square to include the sweep of the radius. This increases the measurement of the square to √1.412.

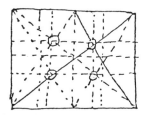

To divide the newly created rectangle in the proper manner, run a diagonal from one corner to the opposite. Then run a line which bisects this diagonal and arrives at the center of the rectangle. The dotted lines show the other possible diagonal lines, plus the correct horizontal and vertical lines. There are four points (circled) that become the main foci in the design.

Fig. 27

❖ IF YOU NEED A SOURCE OF IDEAS FOR ARRANGE-ments of this kind or for any kind of flat-background arrangement, you can draw upon the design system known as **dynamic symmetry.** Dynamic symmetry is the name given to a study made by Jay Hambidge and published during the early years of this century. The study was meant to explain how the Greeks, Renaissance artists, and later designers made use of specific design principles and achieved perfect results each time.

Hambidge examined such natural design elements as the manner in which petals swirl around the surfaces of sunflowers, pinecones, and other natural forms. He discovered that the individual shell chambers in that marvelous product of the sea, the chambered nautilus, spiraled outward in the same ratio as did the ridges in a ram's horn or the wooden petals on a pinecone. From this, he devised a principle using the **Golden-Mean Section.** Combining elements of the golden-mean section, he created the basic linear formula for dynamic symmetry. Using dynamic symmetry, you can design a composition for any two-dimensional arrangement.

To a certain extent, grid patterns follow many of the tenets of dynamic symmetry. Virtually all of Hambidge's research was in print by the mid-1920s. It was seen by American artists as a godsend and was taught as the prime means of making pictorial compositions in American art schools and colleges as late as the 1940s. After midcentury, however, it fell into disuse; artists and teachers felt it was too limiting because so many students were únable to create a good composition without using it. It has had enormous impact on twentieth-century Americans because almost all of the American Regionalist artists (such as Grant Wood, George Bellows, Thomas Hart Benton, John Steuart Curry, Andrew Wyeth, Peter Hurd, and Edward Hopper) used compositions based on the grid designs of dynamic symmetry.

From the artists, dynamic symmetry was picked up by industrial designers, decorators, commercial artists, and practically anyone involved in visual design of any sort. The fact that it creates an enormously satisfying and pleasing composition, which the proverbial nine out of ten people prefer, has given dynamic symmetry a staying power well beyond the average for such vogues.

For a good understanding of Hambidge's theories, it is necessary to read one of his books (see "Selected Readings"). The books are all out of print now, but copies can probably be found in your local library.

By placing items or pictures over the main focal points of Hambidge's dynamic grid and by arranging works on the connective lines, it is possible to create a highly attractive display design that will be admired by yourself and by most people seeing it.

A very superficial description of dynamic symmetry is shown here. Figure 27 illustrates how the basic, $\sqrt{1.412}$ golden-mean rectangle is formed. As you can see, this is a very unwieldy crutch with which to become encumbered, but if it serves your purpose, use it as you can.

SCULPTURE DISPLAY

❖ SCULPTURE IS THE ART OF CREATING IN THREE dimensions or in relief. Sculpture is best seen in strong, contrasting light and shadow. When sculpture is displayed in a full flood of light, it is very difficult to establish the form properly to one's satisfaction. Also, when the only source of light is from directly overhead, there is distortion of the sculptural form. The piece needs a balance of light and shadow to be seen to advantage.

Full-round sculpture is the term used to describe a piece finished on all sides. **Relief sculpture** is a piece modeled only from the front, and perhaps the sides, meant to fit flush against a wall. Therefore, full-round sculpture should be positioned so that you can see all of its sides. Relief sculpture can be attached to or hung on a wall.

Sculpture is made of just about any material. The most common are stone, metal, and ceramic. Ceramic means that the work is of

fired clay: earthenware, stoneware, or porcelain. Terra cotta, a reddish or buff-colored substance, is also fired clay. Woods, metals, cloth, bone, glass, paper, plastic, and any combination of these materials are all used for sculpture. Some of the materials are more fragile than others.

Unless you have a large collection of sculpture (for instance, Pre-Columbian terra cotta or African primitive), the sculpture is best displayed singly or in very small groups. A piece of sculpture can be used for an amazingly dramatic effect when properly lighted, or it can add charm, such as with a Dresden porcelain figurine in a display cabinet. Today, many people collect the architectural sculpture removed from demolished buildings, and they use these pieces with pictures and other objects in group arrangements most effectively.

In lighting sculpture properly, try to get a direct beam (spotlight or floodlight) from a forty-five-degree angle above, plus a softer sidelighting (window, lamp, etc.). If the sculpture is dark, it looks better against a light wall (seen with the wall closing the view behind it); if the piece is lighter, it will be seen better in a darker environment. Plastic sculpture is usually meant to be lit from beneath, but most sculpture looks better if lit from an angle above, giving a normal, daylight effect.

Most sculpture is placed on a tabletop, ledge, or cabinet top. Few people in private homes take the initiative to provide a sculpture with its own **pedestal** (not the base, but a pedestal that rises from the floor). Most of us have neither the time nor inclination to find the space or proper support for sculpture. We feel fortunate to have pieces displayed on a handy shelf. However, if you have a good piece of sculpture, it deserves its own pedestal support, much as a picture deserves its own frame.

Traditional or antique busts and full figures in small sizes look excellent on pedestals dating from the historical period of the piece itself (fig. 28). These pedestals are usually carved marble or wood, often articulated with gilding or applied gilded-bronze ornamentation. Such a pedestal is really a work of decorative furniture art in itself and is quite often very expensive. Pedestals that approximate the antique type may be made fairly cheaply out of shaped blocks of

Antique Pedestal Types

Fig. 28

wood and attached moldings, then painted to suit the piece of sculpture. Pedestal-like architectonic fragments, found in the building demolisher's yard, can easily be tailored to fit the piece at hand. Modern sculpture looks best on absolutely plain rectangular or cylindrical standing pedestals, usually made from plywood or particle board and painted, but also made from plexiglass (fig. 29). The only trouble with a plexiglass pedestal is that sometimes it makes the piece seem to float, and when the work gives a heavy effect of mass, this becomes unsuitable.

When faced with the problem of displaying a group of very small sculptures (ranging from two or three inches high to about six inches high) that you do not want to put in a vitrine cabinet, get plexiglass cubes, open on one side. By making a sort of building-blocks arrangement, you can create an exceptionally good, inventive display sensitive to the problems of the sculptures' miniature sizes. Such a showing can be placed on the top of a shelf or cabinet with most effective impact. Some of the sculptures can be placed inside the cubes, others on top of the cubes, and so on. This is also an extraordinarily good way of displaying glass paperweights that you don't want in a tabletop arrangement.

Modern Pedestal Types

Fig. 29

A FINAL WORD

❖ A FINAL WORD ON DISPLAY ARRANGEMENTS AND intentions: whatever your plan, it should look natural, easy, obvious, and definitely not contrived. Displays should be planned to keep original artwork as safe from human and natural hazards as possible, because damage so inflicted is usually very expensive to remedy. When you hang pictures above a cabinet, fireplace mantelpiece, or other shelf or ledge where three-dimensional objects might also be displayed, try to keep the bottom edges of the picture frames from being visually overlapped by the three-dimensional works. This lessens the accidental introduction of clutter, which is a detriment to a good display. Don't overcrowd group arrangements, especially in a display cabinet. And last, if you create an effect you don't like, it is not permanent — you can always change it.

INSTALLING YOUR ART

CHAPTER FOUR

Well, I see you finally got it hung!

BASIC TOOLS

Headed Nail

Fig. 30

Picture Hook #1

Fig. 31

Picture Hook #2

Fig. 32

48

▲ THE CHIEF TOOLS YOU NEED FOR HANGING PIC-tures are a good, heavy-duty, steel hammer (an aluminum-headed hammer tends to break); a six- or eight-foot steel measuring tape; a small oil level; patented picture hooks and nails; regular-headed nails; a pair of needle-nose pliers (optional); wire cutters (optional); and a desire to obtain the best possible effect from your labor. Sculpture installation needs little other than something to place the sculpture on and perhaps cardboard for shims. Display-case installation needs primarily a good design. If you choose to install fabrics in your display case, you need staples or wheat-paste glue to attach the fabric to the inside of the case, or you can affix the fabric onto a sheet of wallboard and insert that behind the shelves.

A number of patented picture hooks and nails are offered on the market. It is better to use a picture hook, rather than a nail, because the hook is designed to change the direction of the weight suspended from it, pushing the weight into the wall and then down, rather than just down as a nail does. A plain nail (without benefit of a picture hook) directs weight straight down and usually slightly away from the wall (fig. 30). In a wooden surface, a nail is acceptable, but in plaster or plasterboard, a nail tends to give way, pulling easily from the wall. It takes a larger nail to support the same weight that a smaller nail and picture hook combination will support.

The two chief types of patented picture hooks are shown in figures 31 and 32 to illustrate how this weight distribution applies and how the weight distribution differs from using a plain nail without a picture hook.

The patented picture hooks come in packages that list the weights they will support. Few pictures weigh more than twenty pounds; most weigh two or three pounds. However, when hanging a large work in an ornate, hand-carved, gilded wooden frame or in a frame fabricated in molded plaster and gilded or given other surface-treatment coloration, the weight can increase considerably. A work framed under glass will weigh more than an equivalent unglazed work.

When hanging a large, heavy work, it is better to use two picture hooks — one on either side of the work — inserted directly into the

screw eyes to which the framer normally attaches the picture wire. When using this system, it is best to remove the unused picture wire because it sometimes blocks the space in the hole needed for the hook end of the picture hook. The wire might also abrade the reverse of the picture. The double-hook method of hanging has another advantage — to insure that the picture does not tilt. A third advantage, if the picture is quite heavy, is that two picture hooks use smaller nails than one large picture hook.

When nails cannot be driven into the walls (because of rules in an apartment house or rented property), there are alternatives. If a molding is used at the top of the wall — visually dividing the wall space from the ceiling plane — or if there is a molding placed down the wall a short distance from the ceiling, you can make use of **S hooks,** designed to fit the shapes of most such moldings. In buildings dating from the late nineteenth century until the 1920s or 1930s, such moldings were called *picture moldings*. They were designed to support the weight of pictures suspended from them on long wires fastened at the bottom to screw eyes on the reverse of the pictures. If your space has such moldings and you cannot for some reason put a picture-hook nail directly into the wall, S hooks are your best answer.

To attach the picture to the S hook, you should use nylon fishing line instead of heavy, visible, and not particularly attractive steel wire. Fishing line thick enough to support a fifty-pound test weight is virtually invisible from a couple of feet away. Using fishing line works best with two lines, one fastened to each screw eye at the bottom end and fastened to the S hook at the top, directly above. The method of using one very long line, attached at either end to the screw eyes and supported in the middle from the picture molding, is not very safe because the edge of the S hook, which holds the line, is usually fairly sharp and can cut the line unless it is wrapped around the hook several times. When using the fishing-line method, make certain that the line is tied securely to the screw eye and to the hook. If you don't know how to do this, ask any fisherman who has ever tied his lure to the fish line. It is the same procedure.

During the late 1940s, another type of suspension hook

appeared on the market, the **hanging rod.** This is a square-sectioned steel rod, about one-fourth-inch square and six or eight feet long. The top end is shaped to hang from the picture molding. Along the rod, you can slide one or more clamp hooks designed to support the picture wires. This would allow double hanging, but the rod has certain undesirable effects. The clamps have been known to slip, even when securely fastened according to the manufacturer's directions. Since the back of the clamps keeps the rod slightly away from the wall, the rod can wobble, allowing the pictures to hang in a slightly different plane than the wall. Hanging rods are not very attractive, and you will probably want something less obvious.

SCREW EYES AND WIRE

▲ MOST FRAMERS ARE VERY CONSCIENTIOUS ABOUT placing screw eyes and wire in the proper place on the back of a picture. However, it is wise to know where the screw eyes should be placed and why. In today's living or working spaces, pictures look best when displayed with their surface planes as parallel to the wall plane as possible.

In the nineteenth century, pictures were often hung at an angle away from the wall plane, because residue from gas lighting produced black soot that clung to everything, especially picture surfaces. The Victorians habitually put glass over all pictures, whether works on paper or oil paintings. To reduce reflections, they tilted pictures at an angle away from the wall. Sometimes this angle was as much as forty-five degrees from the vertical.

This practice persisted long after its original justification, and even after electric lighting came into universal use, many older people were still hanging pictures at an angle. The Victorians got their pictures to hang at these sharp angles by putting the screw eyes near or below the centerline point on the frame. ***To keep a picture from tilting out at the top, position the screw eyes somewhere between one-quarter and one-third distance from the top edge of the reverse side of the frame.***

The wire also plays a part in the angle of a hung picture. If the wire is so long that, when pulled upward as if hanging from a hook, it comes within an inch of the top of the frame, the picture will tilt out from the wall. If the picture is fairly large, it will need a picture hook at least one-and-one-half inches long, top to bottom. If the wire reaches an inch from the top of the frame, the picture hook will show above the top of the frame.

For hanging a picture on a single picture hook, the best method of stringing the wire is to make it fairly short, but long enough to get your hand under it to place it over the hook end of the picture hook. If a picture is as much as three feet wide or weighs fifteen to twenty pounds, it is best to use two picture hooks in the manner noted earlier.

Over the years, I have noticed that amateur or semiprofessional artists often use very small screw eyes and thin, weak wire on a picture, especially one that is glazed. Stinting on screw eyes and wire is absolutely the wrong place to practice economy. These are the items that will keep the picture from falling. Conversely, overly large screw eyes and thick, heavy wire are not needed on small pictures.

The framer is the best advisor in most cases, but if you work without benefit of a framer's advice, use these guidelines: ***for a picture that weighs between five and ten pounds, use a screw eye that has a screw shank at least three-eighths of an inch long and an eye that is at least one-quarter inch in diameter; the diameter gauge of the extruded steel wire used for manufacturing the screw eye should be at least one-eighth inch thick.*** Don't fall into the trap of using the tiny, oval screw eyes unless the picture weighs under half a pound. These minuscule screw eyes are not long enough in shank to grip the framing material. Even though the larger ones will project a bit behind the frame (and thus keep the picture from hanging flush with the wall), they are safer to employ and, in the long run, will not produce the troubles that the too-small ones create.

FRAMING

▲ As has been said, the frame is used on a picture to protect it. A frame can be plain, elegant, fussy, ornate, metallic, or even plastic, but it must protect the work it confines. During the 1950s and 1960s, when many practicing artists used simple slats of wood, nailed onto the stretcher of a painting to serve as a sort of finish around the painted surface, one got used to seeing screw eyes mounted directly into the stretcher. This is to be avoided whenever possible because the stretcher is the chief physical means of maintaining the tension required to keep the painted canvas taut. A screw eye can easily split a painting stretcher, or if the shank is too long, it can pierce the canvas from the reverse side. Either of these things is enough to cost a lot of money in repairs.

When affixing a painting into a frame, you should first make sure that the rabbet (the recess into which the painting fits) is clean and smooth. After placing the painting into the frame, be very careful not to nail through the stretcher into the frame. This shortens the life of the stretcher and thus the life of the picture. If the back of the stretcher is flush with the back of the frame, steel straps (about three or four inches long) can be screwed across each corner of the frame, on the diagonal, to hold the corner of the stretcher in place without allowing it to shift. If the back of the stretcher projects beyond the back of the frame, small straps of spring steel (about three inches long) can be screwed to the frame and rotated across the back of the stretcher to hold it securely in place. An average-sized picture of about two feet by three feet needs only one such strap in the center of each side.

Another consideration in framing is backing. Paintings on canvas do not require (and should not have) paper glued to the backs. Paper is glued to the back of glazed pictures to keep insects from entering or at least to deter them a bit. On canvas paintings, an **inert** rigid plastic sheet, about one-eighth- to one-quarter-inch thick, can be fitted under the holding straps along the stretcher. One such product on the market is called **Fome-Cor**® and is available from most good-quality framers or artists' suppliers. Fome-Cor® is made of plastic foam and is constructed with a cellular inner layer that allows air to pass through but screens out insects and dirt.

I'm sorry dear, it's upside down but in exactly the right spot. . . .

Backings are used to keep foreign material from falling into the tight space between the inner edge of the stretcher and the reverse side of the canvas. Such material can cause damaging bulges to appear on the front of the painting and will ultimately cause deterioration of the painted surface. A backing will also help keep a painting safe from accidental pressure from the reverse (another major cause of painting damage). This can occur when you lift a framed picture with one hand and squeeze your fingers against the back of the canvas or when you lean a picture against the corner of a piece of furniture. Too often, a sharp edge can push strongly into the unprotected reverse of the canvas, or worse, actually cut or tear the canvas from behind. And then — $$$$!

▲ NOW, IF YOU'VE GOT YOUR WORK OF ART IN PERfect condition with wire and screw eyes just right, made all your design plans, and have not been scared silly by all the comments on what can go wrong, you are almost ready to hang your picture on the wall. The next step is measuring.

HANGING PICTURES

▲ ONE OF THE QUESTIONS I HAVE BEEN ASKED MOST often regarding an exceptionally good installation treatment is, "Do you really measure everything?" The answer is a good loud "YES!" How many times have you seen (or, alas, been involved with) someone who wants to rearrange the furniture? Perhaps you know from experience that the real intention is to make a room seem larger without taking anything out of it. The problem might stem from the fact that the room was never measured to determine the space available for the volume of mass to put in it.

On a much smaller scale, hanging a picture requires accurate measurements, or you may end up with a wall that looks like a piece of Swiss cheese. Fortunately, nail holes in the wrong place can usually be covered by the artwork, but if not, a little caulking compound and a dab of paint will suffice to mask the holes.

MEASURING

▲ INSTALLING YOUR ART

EYE-LEVEL PLACEMENT

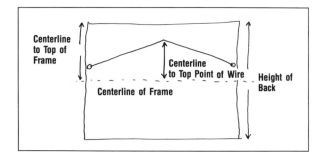

Centerline to Top of Frame

Centerline to Top Point of Wire

Height of Back

Centerline of Frame

▲ To hang a picture at standing eye level, take the following steps:

1) Determine your eye level on the wall by measuring the distance from the floor to the line on the wall that is even with your eye level. The eye level will be where the centerline of the picture goes.

2) Measure the greatest height of the frame, from the back, and divide this measurement in half. This determines the centerline of the frame.

3) Pull the picture wire tightly upward, as if it were already hanging from the picture hook.

4) Measure the distance from the centerline to the top point of the wire, as determined in step 3.

5) Add the measurement from step 4 to the eye-level line on the wall. This is where you put the picture hook.

There is a possible leeway from side to side of about one-half to one inch where the picture can hang without tilting. A final adjustment, after you've put the picture in place, can straighten any crookedness. The picture wire will slide easily on the hook for this adjustment.

If you are double or triple hanging in a vertical stack, an easy way of getting proper placement is to position the lowest picture correctly, remove the picture from the wall, and measure the next picture above from the bottom of the picture to the taut picture wire. Add to this measurement the space you want between the pictures. Add this combined measurement upward from the first picture hook. That is where the second (upper) hook will go, and so on up the wall. You can, of course, start with the uppermost picture, but it is somewhat easier to start with the lowest one.

If you wish to mark the wall before putting in the nail so you won't lose the exact position, use a light pencil mark. This can easily be erased, but it's difficult to erase a ballpoint pen or other more permanent mark. If the art is being hung on a fabric-covered wall where the cloth has a loose weave, such as burlap, mark your place with a small nail — preferably a slightly bent nail — inserted into the

weave at the correct place. Remove the nail before making the picture hook secure against the wall.

▲ IF THE ROOM WHERE YOU ARE HANGING PICTURES IS subject to vibrations from outside traffic or other types of heavy vibrations, it is much better to use the double-picture-hook method (one in each screw eye) to keep the picture level. If you cannot or don't want to do this and if your wall surface is fairly durable material (not wallpaper), make small loops of masking tape (sticky side out) and press one on each bottom reverse corner of the frame, hidden from the front. Then gently but firmly press the bottom edge of the picture against the wall. The masking tape will tend to keep the picture where you've placed it. You may also use rubber, toilet-seat tacks for this purpose.

In order to be sure that you get the picture absolutely level, you can lay a small oil-bubble level on top of the frame molding after you have the picture positioned. Such a level (about four inches long) is a very handy tool when hanging pictures.

Sometimes, especially with older pictures, you will find a frame that isn't square. To hang such a frame with sides vertical may make the top and bottom so off level as to be highly objectionable. In this case, sighting visually instead of using a level would probably be your best solution. Such frames will never be quite right, but you can achieve the best result by not depending on mechanical means.

Round pictures in round frames (as opposed to round pictures in square frames) pose a problem if the framer has not found the correct places to put the screw eyes. Look for obvious horizontal or vertical lines in the composition (such as the horizon line, the outer walls of buildings, the verticality in a portrait pose, or a tabletop in a still life) and place the screw eyes so that any of these elements are as horizontal or vertical as the artist obviously intended them to be. Often, the ornamentation on an old circular frame will help tell you where the top center is.

KEEPING PICTURES LEVEL

COMBINATION DISPLAY

▲ WHEN PLACING SCULPTURE IN CONJUNCTION WITH pictures in a centerline arrangement, the sculpture should be treated as simply another item in the display, with the centerline of the sculpture level with the centerline of the pictures. *Remember to make the sculpture pedestal high enough to insure that the centerline of the sculpture is even with the centerline of the whole arrangement.*

When your arrangement consists of ornately framed antique paintings and sculpture of the same general antiquity as the paintings, and the sculpture is placed on an antique period pedestal (fig. 28), the centerline should be lowered somewhat to indicate that the pedestal is part of the art, rather than letting it be the usual prop. When you have a pair of antique pedestals with pendant sculptures (two works intended by the artist to be seen as one work), the sculpture/pedestal pair would show to advantage flanking a good-sized painting or a fairly large chest. However, for the greatest impact in displaying antique sculpture, use dramatic effect.

MODERN SCULPTURE PEDESTALS

▲ MODERN SCULPTURE LOOKS BEST WHEN DISPLAYED on plain, rectangular or cylindrical pedestals (fig. 29). The pedestals can be made of wood (solid boards, plywood, or particle board) painted or stained to be compatible with the sculpture. The use of clear acrylic-plastic rectangular or cylindrical pedestals is very popular, but when you use a clear plastic pedestal, remember that the pedestal visually appears to be insubstantial and that the sculpture seems to float.

A pedestal is actually an upward extension of a floor space, designed to present the sculpture at eye level. The top platform of the pedestal is called the *floor* of the pedestal. To determine how big this floor should be in relation to your sculpture, *make the floor area slightly larger than the outermost extensions of the sculpture.* This will reduce the risks of damage since the visual mass of the pedestal tends to keep people from walking too close to the work. Portrait busts pose a problem because the width of the shoulders could

necessitate a pedestal width of unsightly size. You must use your own judgment in this case.

Make sure the sculpture and pedestal sit level without wobbling. Either sculpture or pedestal can be shimmed with small pieces of folded cardboard or wood slivers. The sculpture normally has a **sculpture base** of wood or stone screwed to the bottom of the piece. These bases usually have felt covers affixed to the underside to protect surfaces from scratching and to assist in leveling. It is not a good idea to put metal glides or rollers under a pedestal bottom because the glides or rollers can allow a casual jarring to become a major catastrophe — the pedestal might scoot under a light pressure, upsetting the sculpture.

Generally, sculptures are not fastened to their pedestals. There is no great need if the pedestal is the proper size, and the chance of damaging a sculpture while trying to fasten it securely is high. If, however, it is necessary to fasten a sculpture securely to a pedestal (an option which almost always requires the pedestal, in turn, to be fastened securely to the floor under it), there are a number of methods. If you can put screws into the pedestal floor, one way is to place step-clamps on each side of the base, tightly screwed to the pedestal floor at the bottom ends of the clamps. These clamps can be either plastic (virtually invisible but easily broken) or plastic-covered metal. Where the clamps come in contact with the base, they can be covered by plastic sleeves or separated from the base by tiny strips of foam rubber. Flexible plastic tubing in a variety of sizes can be shaped into sleeves to fit over the clamps. The plastic tubing used by most museums to fit over metal clamps is actually the clear plastic air-hose tubing used in home aquariums. The step-clamp method is the most widely used manner of securing sculpture to pedestal, but in some cases, dowels, pegs, or screws in both the pedestal and the sculpture base are the solution. The more elaborate methods of securing the sculpture to the pedestal should be handled professionally. Your local art museum could advise you best on these methods.

▲ INSTALLING YOUR ART

DRAMATIZING DISPLAY CASES

▲ THE ARRANGEMENT OF OBJECTS IN DISPLAY CASES has been covered in chapter 3. If, however, you want to give object display the drama museums use to set off their finest silver, porcelain, goldwork, glassware, and objets d'art, the secret is to use fine fabrics to line cases. Most of us have seen a nicely wrinkled, draped, or pleated arrangement of rich cloth under a precious object, as in jewelry stores or china departments of retail stores. The implication is that the object is so rare and valuable that this kind of emphasis is needed and warranted. However, this treatment draws attention to the cloth at the expense of the object. The cloth also creates an unstable flooring for the piece, which cannot sit securely on the shelf or floor of the case.

Stretch the cloth, or hang it without pleats or drapes, on the inside back of the case and, if desired, on the sides. It can also be stretched tightly across the bottom shelf if the fabric-covered surface still provides a smooth, level flooring for the objects. The cloth should be one color rather than multicolored, which would draw attention away from the objects.

If a patterned surface is desired, it would be best to use a damask fabric. Damask is woven in smooth and textured designs in all the same color. Plain silk and linen are good fabrics to use because there is no pattern other than the weave. If you are displaying Chinese objects, silk is almost a requirement. Primitive sculpture, masks, and folk objects look good against rougher materials such as burlap.

Choosing the proper color is very important since the color can set off the objects or fight them. For example, if you display a group of small, antique bronze sculptures, which are greenish-brown, use a muted yellow or gold silk, linen, damask, or synthetic fabric because the muted yellow tone is richly compatible with the old bronze color — the bronze was originally gold before it aged, and some golden highlights may still show faintly.

A word of warning about using synthetic materials: if the display case is lighted from within or receives strong light from an exterior source, synthetic fabrics may fade very quickly. Burlap also fades rapidly unless you use the natural hemp color. Fine-quality natural fabrics do not fade as quickly.

▲ DISPLAY CASES LIT FROM THE INSIDE LOOK BEST with glass shelves. Light passes easily between the shelves, and if the source of light is at the top front, a minimum of shadows is cast by pieces on the shelves. In using this method, place objects on the top shelf close to the back wall of the case. On each successive lower shelf, place the objects slightly more forward so that the objects on the bottom shelf are quite close to the front plane of the case. By doing this, the shadows cast from an upper object fall behind a lower one. For a more even light throughout the case, the use of additional vertical side lights or fluorescent tubes is often preferable, particularly in tall cases. Sidelights can be masked to hide the visible light source. If you use fluorescent tubes, be sure to protect the objects and decrease the fading of the fabric by placing plastic ultraviolet filter sleeves over the tubes.

When you use a display case with solid shelves, a light source for each shelf is needed to produce a desirable lighting level. This can be done by attaching a small, shielded tube light to the front center above each shelf. The fixture for a lower shelf is fastened to the bottom of the shelf above. Additional shielded sidelights are usually necessary to obtain sufficient light.

In display cases with glass doors, light can build up heat inside. Ventilation should be provided, especially if you are showing organic materials (wood, textiles, bone, paper, etc.). Stone, metal, glass, and ceramic objects are less sensitive to heat. Ventilation can be as simple as a series of one-half-inch diameter holes drilled across the top of the case at the rear.

DISPLAY LIGHTING

▲ ORIENTAL ART, WITH THE EXCEPTION OF SCREENS and scrolls, can be treated as any other type of two- and three-dimensional art regarding the proper display and installation methods. However, Oriental screens and scrolls are normally displayed by Westerners in a manner completely alien to Eastern usage. The Chinese and Japanese use screens and scrolls in their daily lives on a very temporary basis. A screen may be taken from storage and used to

DISPLAYING ORIENTAL ART

create the proper atmosphere during an important banquet and then put carefully back into storage. A scroll may be carefully unrolled, hung from the special viewing rack designed for this purpose, and examined by the owner while a particular poem is read. Afterwards, the scroll is carefully rerolled and put safely away while another may be brought out for reading.

The screens and scrolls are extremely fragile. They are painted in colored inks, often on gold-foil paper (screens) or rice paper glued to metallic-threaded damask (scrolls). The screens are mounted on thin wooden frames coated with many layers of shiny, brittle lacquer. The scrolls are weighted with rollers of ivory, jade, cinnabar, malachite, and lapis lazuli. These are treasures, indeed!

To simply put a frame around a completely flattened screen or fasten a hanging scroll permanently in a shadowbox seems a desecration. However, most Westerners do not have the inclination or the space to arrange a screen as a self-supporting unit or to unroll scrolls only on special occasions. There are solutions that, although not historically correct, can serve our needs.

SCREENS

Fig. 33

▲ THE USUAL ANTIQUE (SIXTEENTH- THROUGH NINE-teenth-century) Chinese and Japanese screens found in American collections measure about three to six feet high by four to eight feet long. Each panel is usually about twelve to twenty inches wide. The

Wall

16"

Cork Lining

Screen

Fig. 34

method of display that somewhat approximates historical accuracy consists of arranging the screen as a self-supporting unit, lifted so that the centerline is at eye level. This is done by supporting the screen on a shallow wooden ledge or shelf with a lip on the edge away from the wall (fig. 33). The shelf should be lined with cork sheeting or other nonslippery substance that is compatible with the materials of the screen. The shelf should be about sixteen inches from front to back and as long as the screen is when measured flat. When the screen stands on this shelf with the panels in accordion position, the shelf

Fig. 35

Foam Rubber

Flattened Screen

Cork Flooring and Pad at Front

4"

Cork Pad between Screen and Shelf Lip Flattened Screen

1" Air Space behind Screen

will be about eight inches longer than the screen (fig. 34). The hazard of this kind of display is that the screen is not fastened or secured to shelf or wall and might be accidentally knocked over.

A less bulky, historically inaccurate method is to flatten the screen against the wall, supported on a four- or five-inch-deep lipped shelf as long as the flattened screen, lined with cork sheeting (fig. 35). Additional strips of cork should be placed as padding between the bottom edge of the screen and the shelf lip and between the screen and the wall (fig. 35). The screen should be positioned about an inch away from the wall to allow circulation of air behind the screen minimizing potential damage from mildew and mold. An *L molding*, available from any lumber company, is placed across the top of the screen and screwed to the wall. The L molding should be padded with foam rubber on the inside where it touches the lacquered screen frame. The molding must not put any downward pressure on the screen.

SCROLLS

▲ THE SIMPLEST AND EASIEST METHOD OF DISPLAYing a hanging scroll is to hang it from a headed nail. Drive the nail into the wall so that the nail angles upward slightly and projects from the wall about one inch. Put the braided cord that is normally fastened to the rigid top slat of the scroll over the nail and gently unroll the scroll down the wall. Make sure that the ornamental cloth strips that are fastened to the rigid slat on the front side are allowed to hang down the front of the scroll. These two strips are designed to balance the visual mass of the painting on the scroll and draw the viewer's attention up to the top of the scroll (fig 36). Scrolls are usually meant to be read from top to bottom.

This method of hanging a scroll gives no protection whatever to the scroll. Unprotected in any way, the scroll is liable to receive any kind of accidental damage. Interior humidity tends to make the sides of the scroll curl inward, and too little humidity tends to make the glue become excessively dry, crinkling the surface of the painting. A plexiglass shield, projecting a couple of inches beyond the outer

dimensions of height and width overall, can be secured in front of the scroll so that it does not touch any of the surfaces of the scroll or its bottom roller to minimize damage from touching. However, this method does not solve problems of climate.

A method often used to display a hanging scroll is the use of a shadow box. The method outlined above is essentially a shadow box without the top, bottom, or sides. A shadow box is a shallow box used for the display of three-dimensional objects hung on a wall. A hanging scroll, because of its top slat and heavy bottom roller, is three-dimensional. The interior of a shadow box can be covered with fine silk or damask compatible with the rich fabric used on the scroll itself. If you use a shadow box, several small holes must be bored through the top and bottom projecting elements to allow a slight circulation of air through the box but not enough to cause curling from excessive humidity.

This Oriental-type hanging scroll, with a heavy roller weighting the bottom, is shown hanging from a single, headed nail. The woven tie cord hangs out of sight behind the scroll, while the decorative ribbons hang down the front.

Fig. 36

HAND SCROLLS

▲ ORIENTAL HAND SCROLLS ARE NOT OFTEN FOUND in Western private collections. A hand scroll is much like a hanging scroll except that it is meant to be seen horizontally instead of vertically. Also, instead of presenting just one scene, a hand scroll normally illustrates a series of connected events (as in a modern cartoon strip). A hand scroll is meant to be used while the viewer is seated, holding both ends of the scroll in the hands, and unrolling it to the left. The greatest amount of picture exposed at a time is about three feet. Hand scrolls can be as short as a couple of feet and as long as the artist felt necessary — sometimes fifty or sixty feet.

In my opinion, a hand scroll should not be placed on long-term display, but if you own one and want to show it along with the art objects in your home on a more or less permanent basis, the following method will possibly cause the least damage to the work. The damage, incidentally, comes from light exposure, gravitational pressure on the bottom side of the partially unrolled scroll, and the vagaries of climate inside the display case.

On the top of a table, cabinet of similar height, or a specially

constructed stand, arrange a sheet of clear, colorless, rigid plastic measuring three feet long by a couple of inches wider than the height of the scroll. Lift up the back side of the sheet so that the surface plane is at an angle of no more than thirty degrees from the horizontal and secure the angle in place by thirty-six degree triangular wedges at each end and in the middle. Affix a three-inch lip at the bottom edge of the sheet (fig.37). Prepare a clear plastic vitrine box to fit over the angled plastic sheet, leaving a clearance of about six inches above the top of the sheet at its highest point.

Unroll the screen to the scene you wish to show and gently place the scroll on the angled sheet. Take two flat plastic strips, each measuring two inches wide by one-fourth inch thick by as long as the space from the bottom lip of the sheet to the top edge of the sheet, and lay one strip at each end of the unrolled scroll against the bottom edge of the roll. These strips should hold the roll open. Then place the vitrine case over the entire set-up, leaving a breathing space of about one-fourth to one-half inch between the bottom of the vitrine case and the tabletop (fig. 38).

Fig. 37

Fig. 38

64

The display should be in the darkest corner of the room, but if there is any great amount of light falling on the case, cover the case with a piece of fine fabric and remove the fabric only when you or another wish to see this rare treasure. You should also change the picture or scene quite often so that there is no light fading in one particular place.

FURNITURE

▲ IF YOU HAVE GOOD FURNITURE YOU WISH TO MAKE the special center of attraction in your home, it should be treated with the usual care given antiques regarding waxing, usage, etc. In placing such pieces, keeping them away from a main traffic pattern in your home will help minimize accidental damage. Don't put your rare Chippendale whatnot in a dark hall where everyone trips over it.

Remember that gilded furniture is made by gluing gold-leaf over **gesso** (a sort of plaster of Paris) which has been applied over carved wood. Such pieces are quite fragile, as are their delicate designs. Strenuous dusting or rubbing on the wood parts will quickly remove the gold-leaf (which is about one-tenth as thick as a piece of tissue paper). Light will rapidly fade the fabrics with which they are covered or will bleach their wooden surfaces. Low humidity (as with winter heating) will shrink and warp the wood, and high humidity will allow wood to expand, breaking corner joints.

Don't fall into the error of automatically having a piece of antique wooden furniture stripped of its old varnish. The color, referred to as **patination,** is one of the means the dealer uses to set the price. ***Stripping a piece of furniture in good, antique condition can also strip the monetary value down to zero.*** Part of the pleasure of owning antiques (or works of art of any type and period) is learning as much about them as possible. Only when you know what an antique should look like can you determine if the surface ought to be changed or left alone.

The best use of antiques is to use them. They were made for use and, with a certain care, will long outlast modern furniture.

It may be unique . . . and it may be functional, but I don't think it would look good in the front hall.

✔RECORDS
AND APPRAISALS

CHAPTER FIVE

*It's as important to keep good records on
your art as it is to display it well.*

 # RECORDS AND APPRAISALS

DOCUMENTATION

✔ AFTER ACQUIRING ART OF ANY TYPE, MEDIA, OR variety (including reproductions), it's a good idea to keep records on what you own. Records not only help you know the range of what you've obtained, but in making up the **documentary card** or sheet and filling in the information, you learn a great deal about the artist who created your work of art and about the work itself.

Recordkeeping, invaluable when having your art insured or replaced in case of accidental loss, should go hand in hand with owning art. Admittedly, few of us take the time to make these records prior to loss or damage, but most of us "always meant to do so." One of the major obstacles that keeps us from making records is ignorance on how to go about it.

We probably carry life insurance on ourselves and on our families. We probably have our household objects insured, and certainly must, by law, keep our automobiles insured. Keeping records on an art collection is closely related to keeping records on insurance policies. In both cases, records assist us during the trying moments of actual loss or damage, and in the case of making and keeping records on an art collection, the records can make the heartache and headache of loss of art a great deal less formidable. These points hold valid even for commercial reproductions, which, although replaceable, have a certain monetary value for the initial purchaser.

I know of a couple who inherited a fine collection of original paintings and antique furniture. This collection stimulated their interest in all art. Although they did not have the funds they felt were required to obtain additional original artworks, they began to buy commercial facsimile reproductions of paintings they admired.

As time passed, the couple assembled a very large collection of reproductions, including so many schools of painting, periods, and nationalities that eventually their reproduction collection reached the proportions of a genuine teaching aid. Few people take the time to put together a good, educational selection of facsimile color reproductions. However, this couple, because of their interest, made just such a collection.

They very shortly discovered that to cover the field as they wished, it was imperative to keep records of what they bought. On 3"

by 5″ file cards, they recorded the artist's name and nationality, birth and death dates, title of the original and any alternate titles, size of the original and of the reproduction, location of the original, whether they had visited the location housing the original, whether they had seen the work, the date they bought the reproduction, and how much they had paid for it.

By the time the couple had sufficient funds to acquire more original art, they were extraordinarily well informed on art, and they had an amazingly complete collection of high-quality reproductions, many of which were no longer available on the commercial market. They did not frame and hang these for display. They dry-mounted the reproductions and used them as learning aids, like books.

For the owner of original artworks, recordkeeping is vital. An insurance company normally requires updated valuations for most itemized coverages. Setting up records and keeping them current takes little time and can prove to be a fascinating adjunct to owning art. You may keep simple records, as did the couple mentioned above, or you can make more elaborate records similar to those kept by museums.

The best source of information for records comes from the dealer from whom you buy the work of art. Usually this kind of information is furnished on the bill of sale for the work or on an added information sheet provided at the time of purchase. A certain amount of the information can be obtained from the work itself: precise measurements of height and width, exact location of the artist's signature (if present), date of work and location on work (if so given by the artist), condition of work at time of purchase (framed, unframed, has clean varnish, needs varnish cleaned, etc.), and other information about the physical condition of the work. If you have leanings toward being an art detective, it's very rewarding to find out as much as possible about the artist and his style of work. You may do this by visiting the local library and reading on the subject. You can also find other people or institutions who own your artist's work. Because most owners are quite happy to know more about the items they own, you can exchange information with them.

✔ RECORDS AND APPRAISALS

PHOTOGRAPHIC RECORD

✔ YOU SHOULD OBTAIN A GOOD-QUALITY BLACK-and-white **documentary photograph** of your artwork as soon after you buy it as possible. Usually the dealer can supply the photograph, normally at no extra charge. Black-and-white photos are preferable because color photography is so uneven and undependable. Black-and-white photos are also less expensive. What you need is simply a good photographic record of your work, invaluable for insurance purposes if the need ever arises.

ACID-FREE PAPER

✔ FOR GOOD RECORDKEEPING, USE PAPER THAT DOES not crumble and disintegrate over the years. Typing paper, file folders, and file cards in a variety of sizes are made in acid-free paper, which does not turn dark, dry, and crumbly, and will survive in good condition for centuries. Most acid-free paper made today costs about the same as non-acid-free, wood-pulp paper. Typing paper labeled *rag bond* is basically acid free, sufficient for permanent records, and is available at most stationery stores. Acid-free file folders and index cards are not so easily found, but they can be ordered by your stationery store, or you can write one of the suppliers listed at the end of this book.

DOCUMENTARY RECORD

✔ *THE INFORMATION THAT SHOULD BE RECORDED ON the documentary information sheet (fig. 39) is as follows:*
— Artist's full name.
— Artist's nationality.
— Artist's birth and death dates (or birth date only if still living or if death date unknown).
— Title of work.
— Date of work (if known; otherwise, approximate date).
— Medium of work (oil, watercolor, engraving, bronze, stoneware, etc.).
— Dimensions of work. (List height first, then width. For example,

H. 10 x W. 15 inches. Unless you are a metric-measurement fan, list dimensions in inches and feet.).
— Whether work is signed, and if so, record exactly how signature appears on work.
— Location of signature (be sure to note if there are additional signatures on the reverse).
— Any other marks or inscriptions, and where located on work.
— Previous ownership (museums call this **provenance**); list in chronological order from earliest time to your ownership. List dealers

```
                                    INVENTORY NUMBER _____
           DOCUMENTARY INFORMATION SHEET

COLLECTOR'S NAME _____
                 _____

ARTIST'S FULL NAME:               DATE OF PURCHASE:

ARTIST'S NATIONALITY:             PURCHASE PRICE:

ARTIST'S LIFE DATES:              DEALER'S NAME:
                                  ADDRESS:
TITLE OF WORK:                    TELEPHONE: (   )   -

ACTUAL (or approximate) DATE OF WORK:

MEDIUM:

DIMENSIONS:  H.        x W.     inches;  DIAM:      inches

SIGNATURE:

LOCATION OF SIGNATURE:

MARKS/INSCRIPTIONS:

LOCATION OF MARKS/INSCRIPTIONS:

PREVIOUS OWNERSHIP:

CONDITION AT TIME OF ACQUISITION:

REMARKS:

PHOTOGRAPH:  ___black and white;  ___color print;  ___color transparency

DATE INFORMATION SHEET COMPLETED:        BY WHOM:

PRESENT VALUE:  $_____
(Note present value in pencil and keep current on an annual basis.)
```

BIBLIOGRAPHY:

EXHIBITIONS:

Fig. 39 **FRONT** **BACK**

as well as collectors and the date each previous owner sold it, if you know.

— Condition at time of purchase.
— Date of purchase.
— Cost at time of purchase.
— Name and full address of dealer, including telephone number.
— Current valuation. (You should get work appraised every two or three years by a reputable appraiser. If you keep track of the activities in the auction market, save money and do this yourself; however, you should have a new, professional appraisal at least every five years.)

If your works are major-quality art and you make them available for loans to museum exhibitions, record where they have been exhibited. List the exact name and address of the museum and the exact name and dates of the exhibition. If your works have been the subject of published articles, record this information in the normal bibli-

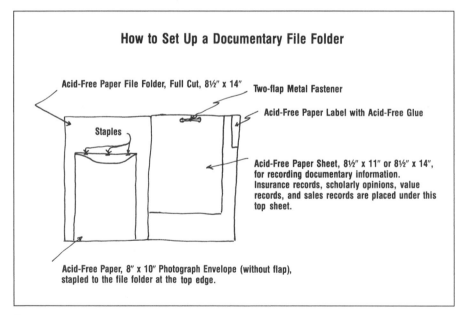

How to Set Up a Documentary File Folder

Acid-Free Paper File Folder, Full Cut, 8½″ x 14″

Two-flap Metal Fastener

Acid-Free Paper Label with Acid-Free Glue

Staples

Acid-Free Paper Sheet, 8½″ x 11″ or 8½″ x 14″, for recording documentary information. Insurance records, scholarly opinions, value records, and sales records are placed under this top sheet.

Acid-Free Paper, 8″ x 10″ Photograph Envelope (without flap), stapled to the file folder at the top edge.

Fig. 40

ographical listing manner, which your local library can explain.

All the above information is called documentary information. When museums use this kind of information sheet, it is called a **documentary information sheet;** each work of art in the museum's collection has a separate sheet, placed in its own **documentary folder** (fig. 40) which also includes all photographs pertaining to that work of art. Whether a private collector wants to get that complicated is a moot point. If you should want to, your insurance company would be delighted, as well as your lawyers and, one day, your heirs.

This kind of complete record is somewhat akin to a complex recipe. Many of us probably keep somewhat skimpy records of the art we own. Skimpy records are like a recipe for stew that says, "Take some meat, vegetables, and spices, then cook." The result could be rather dubious unless you are an expert chef, and then you'd probably throw the recipe away as useless. Many well-intentioned people keep records that, when needed for insurance, legal, or other purposes, are virtually useless. It's so easy to do it right that you should develop the habit along with displaying your art in an attractive and interesting manner.

The complete recordkeeping method used by museums includes 1) the documentary file, 2) a condition report file (updated twice a year), 3) a location file, 4) a storage location file, 5) a photograph file, and 6) an index file. This is mentioned only to illustrate the importance of recordkeeping for an institution devoted to the acquisition, collection, and display of art objects. If you wish to put together a documentary file, your local art museum could be of great assistance to you in finding the proper type of paper, etc. A copy of your records should be kept in a separate place (safety-deposit box or office) in case the originals in your home are destroyed or lost.

One bit of information museums keep in the documentary file is what the critics and scholars say about the work in question. This is a very important item if you, too, want to be sure that what you think you own is actually what you do own. Whether you buy a painting or other work of art for little or much, you deserve to know, as clearly as possible, what you have. This may even be more applicable when you inherit such a work. How do you find out about what you own?

✔ RECORDS AND APPRAISALS

LEARN ABOUT YOUR ART

✔ THERE ARE A NUMBER OF WAYS TO FIND OUT WHAT you own. If you really want to make finding out a learning experience for yourself — and this is probably the most rewarding way because, by the time you finish, you truly know the work at hand and have greatly expanded your awareness of all art of a similar nature — you can read about the artist, examine photographs of other works by him, visit museums that display his work, and become thoroughly conversant with his style.

If you don't know who created the work you own, your local art museum may have a professional staff member who will assist you by at least pointing you in the right direction. Museums may set aside one or more days a month when the public can bring works they want to know more about. The person with whom your appointment is made is usually a scholar in the field of your work of art (a specialist in paintings, sculpture, graphics, or decorative arts). The specialist is usually on the curatorial staff of the museum. He will examine the work from the viewpoint of style and usually can quickly tell you what country it comes from, the approximate date range, what condition it's in, and who the likely artist is. The curator has access to various dictionaries on artists, dictionaries of signatures, and other specialized art reference books. Quite often, the curator will direct you to the museum's library and suggest you consult specific books that will be enlightening for your project.

It is against the usual professional practice for a museum staff member to give monetary appraisals, so don't expect one. The curator may tell you if the picture is valuable enough to proceed with your investigations. You may want to leave it at that, or you may continue the research on your own. In that case, you embark on the detective method mentioned earlier.

USING THE ART CONSULTANT

✔ IF YOU DON'T HAVE THE TIME TO HANDLE THE investigation yourself or to take the work to your museum, if the museum can't provide the service, or if you feel hopelessly inadequate for the job, qualified **art consultants** are available in most

communities across America. Usually your local art museum or the art department of the local college or university can suggest the names of those in your area. An art consultant, like any professional such as a doctor, lawyer, or business adviser, will charge you a fee for her time and opinions. The art consultant will give you a written report on her conclusions (which most museum staff members are forbidden to do) and usually is qualified to make a monetary appraisal of your work. Charges for this service vary widely, but for the better consultants, you can expect to pay several hundred dollars per work examined if the artist is unidentified. The charge will be considerably less if you simply want written verification for an attribution of which you are quite certain.

The art consultant can also advise you on proper framing, if the work needs that, or a qualified **conservator,** if the work is in bad condition. Don't expect the art consultant to repair a damaged work for you. That is a job for the conservator. A good conservator is as highly trained as a good doctor; a good art consultant is as highly trained as a good lawyer. You don't expect medical advice from your lawyer or legal services from your doctor. The same distinctions apply in the world of art specialists.

If you have plenty of time to do your own research and really want to go into the project in depth, you can receive professional training at various schools across the country. More on this point is discussed in chapter 8.

For many of us, research on our own art objects consists chiefly in determining how much money they are worth. This is particularly true if we've inherited artworks or bought them cheaply at estate sales, secondhand sales, or garage sales. We've all heard the stories about the chap who found the masterpiece by da Vinci at the local flea market, and we hope that our great find is worth at least half as much. This story has been told an almost infinite number of times about an equally infinite number of people. It might come as a jolt to discover how very rarely this actually does occur. The other chief culprit in making people think their bargain specials are really fabulous lost works of art is the well-meaning, sometimes envious neighbor who says, "My, that really belongs in an art museum."

Beware if your neighbor says this, for he probably knows less about the work than you do. After all, you had the good sense to buy the work, and your neighbor didn't.

USING AN APPRAISER

✔ FINDING THE VALUE OF A WORK OF ART IS COMparatively easy. Simply engage the services of a qualified appraiser. Finding a qualified appraiser, however, may not be quite so easily done. Appraisers seem to come in all sizes, colors, packages, and abilities. The key word is *qualified*.

Appraisals are based on what a similar work by your artist has sold for at auction, preferably within the last couple of years. The work your appraiser does is to make a search of all auction records in this country and abroad over the past several years. Failing to find results with this, he may consult records on retail sales. If this also produces no result, (that is, if he can't find evidence of a sale recording a similar work by your artist or a similar work in that style if the artist is unidentified), he is conversant enough with art to know a very close approximation of the work's monetary value.

If you have a major, important work of art, which perhaps you've owned for some years or have inherited without a formal appraisal of recent vintage, you might want to consult the experts at some of America's leading auction houses in New York City. The big three are Sotheby's, Christie's, and Phillips. Each has its own specialists, who often travel about the country, by appointment, to make appraisals. If you want this service, the charge is the round-trip travel fare for this person plus 5% of the appraised value (refundable if you sell your work at their auction house within a year's time). Although it would seem this would be the very best appraisal possible, these experts are expensive, and a good, qualified, local appraiser would very likely come up with the same valuation. After all, it is really no secret what the work is worth, if one knows how the art market has been running.

A word of caution regarding appraisals: artworks oriented to your local community may not be worth as much outside your community. A New York appraiser might value your local art low compared to works with a wider national or international interest.

Also, art of certain geographic areas tends to become highly inflated as popular vogues come and go. Since the mid-1970s, for example, painting and sculpture from the American Southwest, by living as well as deceased artists, have appreciated to such rarefied heights as to become indicative of a fad at work. Some of these works have sold for the same amount as works by European old masters, whose sales records have been long established and sustained. It is possible that the southwestern artists' works would not bring the value range elsewhere in the world. This is known as an inflated market, and the high sales values are deceptive.

COMMERCIAL REPRODUCTIONS

✔ WHILE ON THE SUBJECT OF VALUES AND PRICES, you should be warned of a certain current fad regarding commercial reproductions. A commercial reproduction is made by photographing an original work of art (painting or graphic) and mechanically engraving it into a zinc or other metal plate. Nowhere in this process is the artist involved, after he created the original work of art and before the reproduction prints are signed and numbered. These reproductions are completely mechanical, with no artistic sensitivity involved other than attempting to get the colors fairly accurate, which a machine does.

These reproductions are being put onto the market as signed, limited editions, a phrase that once signified bona fide original graphics, each print inked and handprinted and pulled by the artist. An original graphic is usually signed in pencil and numbered (the number tells you which print of the edition it is: 10/150, for example, means the tenth print in an edition of 150 prints). Often containing titles as well, this penciled information is placed below the image. The mechanical reproductions are primarily offset lithographs. It is not financially feasible to make an edition of the reproductions as small as the editions of most original graphics — 150 to perhaps 500. Some artists have made commercially a number of series of 200 each, with each series called first edition, second edition, and so on. Usually all these editions are run off at the same time and simply separated by the commercial publisher or the artist. Quite often, draw-

ings or watercolors are printed this way. When all these reproductions are done, they are still just that — commercial reproductions. The artist's signature does not make the work an original graphic, and often even these signatures, seemingly written in pencil below the image, are also printed by the offset process.

The problems involved in the creation of an original printed work are far different from the creation of a watercolor or drawing. To reproduce the latter varieties and call them original graphics is deception. The trend started in France soon after World War II, but by the late 1970s, the French government passed legislation to forbid labeling these reproductions as originals. Unfortunately, many American regional artists have picked up the trend as an easy way to make an extra profit. The result is that the buyer finds himself paying $300 or $400 or more for a $25 reproduction. When that reproduction goes to the appraiser, the buyer is usually shocked to discover how little the work is actually worth. The Latin phrase *caveat emptor* means "let the buyer beware." Rarely has it been more true than in the present American print reproduction market.

INSURANCE

✔ IF YOU OWN ORIGINAL WORKS OF ART, YOU SHOULD insure them with an itemized fine-arts insurance policy. The fine-arts policy requires that you provide the insurance company with current valuations for each item on the policy. If the works are damaged, stolen, or lost, your insurance company will reimburse you for the amount or percentage of loss according to the amount shown on the policy. Most such policies cost about 1.5% of the total appraised value annually. You may want the appraised value to be the entire replacement cost or only a part of it, but your insurance pays only the amount listed on the policy less the usual deductions.

Many private collectors and museums seem unaware of the fact that if a work has been damaged and the insurance company pays for the loss, that part which is damaged then belongs to the insurance company. This is true even if the work was insured for less than its full value. The insurer must recoup his payment to you for your loss. The

insurance company will ultimately sell the work at a public auction, where you would have the opportunity to buy back your former work with the money the insurance company paid you. After all, the basic purpose in insurance is to provide you with funds to replace your lost or damaged piece. Many an owner has been shocked to discover that a work that has sustained less than 100% damage and has been insured for 50% value now belongs to the insurance company. Put simply, the insurer has bought the work from you at his price. Your insurance agent can tell you how these policies work.

Often these policies cover your works while at home, in the office, and in transit if you are moving or if you are shipping the works separately. Occasionally there are specific places where your works are not covered, for example, public fairgrounds. Again, your agent can explain.

If you lend a work of art to a museum for public display, require the museum to cover your work in its policy coverage while the work is in its possession. This increases the general care in the handling of your artwork while it is at the museum and in transit. If you do not have your artwork insured while it is in your possession, but you lend it to a museum, get the museum or its insurance company to give you a statement in writing that the work is placed under the museum's coverage while in its possession, whether in transit, storage, or on display.

Before you lend a work to a museum (or to anyone or any organization), check the work carefully to examine its condition before it leaves your possession. Check it as thoroughly again when it is returned and immediately report to the borrower any damages or other problems that may have occurred while the work was away from you.

A specific, given work of art (that is not an original graphic from an edition of more than one) is unique. Quite literally, it is irreplaceable if lost or ruined, even though you can find "something almost like it." That exact work, once destroyed, is permanently gone, even if the artist is living and could reproduce a near duplicate for you. Treat the artwork with respect. It will give you, your family, and your friends great pleasure.

HANDLING AND STORAGE

CHAPTER SIX

CRASH

❏ HANDLING AND STORAGE

HANDLE WITH CARE

❏ YOU'VE MANAGED TO PUT TOGETHER A VERY NICE collection of original works of art. Great! You've just been promoted and are being transferred to another city in another state. Wonderful! You call the moving company and when the packers arrive, you tell them you have all this art that needs special packing. They say, "Fine, we'll put all the pictures in nice flexible mattress cartons, stuff your fragile sculpture into the bottom of the pots-and-pans cartons, and . . . " You know your insurance won't cover anything less than *professionally* packed artworks. Good grief! What to do now?

Probably more works of art have been damaged in some degree by accidental and uninformed handling than by any act of nature, war, strife, riot, or the usual exemption clauses in most insurance policies.

The surface of a painting is extremely sensitive and liable to damage. To a lesser degree, so is the painting's reverse side. The frame chips at the drop of a pin, and bronze sculptures should not be touched with bare hands. Glass breaks with the slightest twist of the frame, and handles of antique crockery seem to be designed to snap off at the merest touch. If you accidentally brush two antique porcelain figurines together, they both seem to fracture into a million pieces. Maybe we should leave art to the museum, but NO! We like it and want it around us, so we might as well learn how to handle it properly.

HANDLING UNFRAMED PAINTINGS

❏ NEVER TOUCH THE SURFACE OF A PAINTING WITH your bare hands or fingers. Your skin exudes an oil that keeps it healthy but permanently marks a painted surface. If the surface is even slightly crackled with age, the paint may be slightly loose, and the chance of accidentally chipping off some paint is high. To put the paint back is very expensive, so don't risk it.

If the unframed painting is in oil on canvas, it is probably mounted on a stretcher. If so, carefully grasp the stretcher without touching the surface of the painting or the reverse of the canvas. If the painting is too bulky, get another person to help you. You are concerned with the safety of the piece, not the weight. Don't carry it up

high, but as close to the floor as safety permits. Hold onto the sides of the stretcher rather than the top element. If you are carrying the painting alone, use both hands. Try not to carry it far in this unprotected manner.

If you have to carry the work far, gently and carefully cover the surface with a clean piece of tissue paper over which you place a smooth, light piece of corrugated cardboard cut to fit the stretcher exactly. Place another piece of corrugated cardboard, cut to fit, over the reverse side. Using masking tape, tape the two pieces of cardboard together, putting a piece of paper over the stretcher where the tape would otherwise touch it. Use as little tape as possible; you need only one strip to a side to hold the cardboard in place. Then carry the work using two hands at the sides of the stretcher. If you are going to move the work in your car, lay the painting face up. If you have to ship the work by commercial carrier, ask your nearest art museum for advice on making a crate if you can't manage on your own.

Two Pieces of Three-ply Plywood

Four Pieces of 1" x 2" Strips

Assembled (with lid shown in dotted lines)

Foam Rubber Stapled to Edge Strip

Fig. 41

CRATING

❑ IF YOU WANT TO MAKE YOUR OWN CRATE, CUT TWO pieces of three-ply plywood to measure two inches larger than the painting on all sides. Nail the reverse side of the plywood to 1" by 3" strips of wood, with the 3" side forming the sides of the crate. Line the edges on all sides around the inside with medium-firm foam rubber attached with heavy-duty staples to the wood. Place the cardboard-covered picture inside, making sure it firmly touches the foam rubber on all sides. Then attach the other piece of plywood as a lid, using screws (fig. 41). If the box is fairly large, add a small strip of wood on each face across the center to serve as a handle to accommodate the commercial handlers. If the case is lovely and smooth, with no projections, the handlers will toss it around or perhaps it will slip out of their hands.

Mark the case "FRAGILE" and "KEEP DRY" in large letters. Paint an arrow to indicate the top of the painting and print "THIS END UP" beneath the arrow. Make all these signs on both sides of the

Fig. 42

HANDLING FRAMED PAINTINGS

crate. To assist the unpacker, use the phrases as shown in figure 42. Put your address label (with return address noted) on both sides, and the crate is ready to send.

An additional safety feature with such a carefully made packing crate would be to line the inside with waterproof paper, which can be bought at a building-supply store. This kind of case, with variations in dimensions, is the basic picture-packing crate for framed or for unframed works.

❑ ***NEVER TOUCH THE SURFACE OF THE PAINTING WITH your bare hands or fingers.*** (See "Handling Unframed Paintings.") Always carry the picture with two hands, holding the sides of the frame carefully. If the picture is wider than your body, two people should carry it. Carry the picture as close to the floor as safety permits. If you lose hold of the frame and the picture falls, there is less chance of major damage. By holding the frame from the upper ends of the sides rather than in the middle or at the lower ends, the center of gravity is lower, and the frame is easier to hold and to carry. If the frame is very elaborate, with complex hand carving, gesso, and gilding, try to hold the frame from the reverse side. If the frame has screw eyes in it, and perhaps wire, hold it by the screw eyes or by the wire, very close to the screw eyes. If two people are carrying the frame, both should be on the same side (preferably the reverse side), and each should be fully aware of where the edges and surfaces of the picture are at all times while carrying it.

Never lean a picture, framed or unframed, against the corner of a chair or other piece of furniture. It is very easy to punch a hole through the painting or make a serious dent in the painted surface, either from the front or from behind. These dents are called **pressure dents** and are very difficult to remedy since the paint all around them has become broken and cracked, and since the canvas itself has been slightly stretched away from the painting plane. If you must put the picture down, place a piece of foam rubber or nonskid carpet under the work and lean it against the wall, or a surface longer than the painting is wide, to offer a firm support behind the work.

□ THE BEST WAY TO TRANSPORT A FRAMED PICTURE IS to lay it flat, face up, in the bed of a station wagon, blocked so the picture cannot shift. Place a large piece of cardboard — stiff enough so it won't sag onto the surface — over the painting, supported by the outer edges of the frame. The cardboard should be secured to the reverse side of the frame, using paper under the masking tape where it could touch the frame-finish area. You need only two pieces of tape, one on either side or at top and bottom, to hold the cardboard over the flat painting surface. ***Never cover the surface with a blanket, bedspread, or piece of cloth that touches the painted surface.*** The chance of snagging loose paint is almost inevitable.

□ SHIPPING A FRAMED PICTURE INVOLVES USING THE basic packing crate as outlined and described for unframed paintings. However, the corners of the frame must have additional protection with strips of padded material (fig. 43). The size of the strips depends upon the size of the picture. A strip is usually about four to six inches

TRANSPORTING FRAMED PAINTINGS YOURSELF

SHIPPING PAINTINGS COMMERCIALLY

Surface of Painting

Fig. 43

Corner Padding Strip

Back of Painting

Staples

Frame

Fig. 44

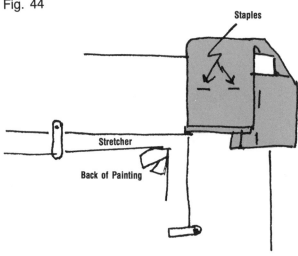

Staples

Stretcher

Back of Painting

wide and about twelve to twenty inches long. A good padding material to use is two-inch-thick bubble-wrap plastic, with the bubbles folded to the inside, leaving the outer surfaces of the strip smooth. If the strip is two inches wide, staple one end to the back, two inches down from the corner of the frame. Angle the strip across the front of the corner and secure the strip to the back of the other side of the corner element (fig. 44).

With the corner pads in place, there is no need for the foam-rubber lining inside the crate. However, you should staple waterproof paper inside the entire crate and lid. The picture should wedge

Surface of Painting

Fig. 45

Painting with corner padding strips attached, placed into packing crate before securing lid in place. Corner pads should firmly touch inside edge of crate. Many picture packers prefer to place the painting with the surface side downward in the crate (as opposed to the way it is shown here in upward position).

comfortably into the crate with a very slight leeway so that if jiggled, the picture can move a fraction of an inch or so. The picture must not be rigid against the inside of the crate, or you will find the work damaged upon opening the box. ***The rule for crating is that the picture must be packed firmly in the crate, but not rigidly (fig. 45).***

If the picture is glazed, the glass must be taped with masking tape. This is done by making either a crisscross grid or a sunburst (star-shaped) pattern (fig. 46). For easy removal later on, the tape should be doubled back just at the edge of the frame. Don't put tape onto gold-leaf, or it will come off when you remove the tape. Never use clear cellophane tape or fabric tape, which is not as flexible as masking tape. If the picture is glazed with plexiglass, it does not need taping. In fact, plexiglass should not be taped because masking tape cannot be removed easily from it.

Some final pointers on handling paintings: if you can avoid it, don't roll up a painting. To do so is extremely hard on the paint film and will crack it badly even if the picture is new. Regardless of how Hollywood thrillers show the villain rolling paintings up, it shouldn't be done. If you absolutely must roll up a picture, never roll it with the painted surface to the inside. This will ruin the picture when it is opened again because most of the paint will have been cracked and will simply fall off. The roll should be no tighter than just to meet the opposing ends of the longest dimension. Keeping all this in mind, it's far easier to carry a picture neatly attached to its stretcher. If you have to roll it tight, you might just as well throw it away and save what little shipping charge there will be. You will have nothing on the canvas except a mass of cracks when you reach the other end of your move.

Fig. 46

❑ PAINTINGS OR FRAMED, TWO-DIMENSIONAL WORKS should always be stored in a vertical position. Oil paintings should not be laid flat since the painted surface is quite heavy and will sag under gravity, causing cracks in the paint film or rips in the canvas. (If there is loose paint, however, the flat, face-up position is best, but the

STORING PAINTINGS

HANDLING AND STORAGE

reverse of the painting must be blocked up inside the stretcher to prevent the canvas from sagging.) Glazed works should not be stored flat since there is a great risk of breaking the glass.

Unframed works on paper should be stored in a horizontal, flat position. If the works are matted, flat storage is better, but in any case, you should lay a piece of **glassine** (inert frosted plastic film) between unmatted works on paper or on the surface of the paper but under the mat window, which will hold the glassine in place.

For flat storage, line the inside of a box (cardboard or wood) with inert plastic sheeting that comes on rolls. You don't want to go to the expense of acquiring good works of art and then store them in a closed space with high levels of acid fumes from non-acid-free paper or wood products. The plastic sheeting is inert, which means it is neutral and has no wood-pulp acid in it, and it will not let acid fumes seep through. However, if you want to be absolutely safe, purchase suitable storage boxes of sturdy, acid-free cardboard from the various firms that make acid-free paper. These boxes are flat, lidded, and available in a variety of sizes.

HANDLING METAL SCULPTURE

❑ THE PROPER CARE OF SCULPTURE HAS LONG BEEN misunderstood by most people. The acidic oil that keeps your skin healthy is ruinous to most art, particularly to metal sculpture. The most common metal used for sculpture is bronze; steel, brass, copper, aluminum, iron, and various alloys are also used. The surface of most sculpture is treated by the artist, or by the foundry under the artist's direction, with a chemical coating called **patina.** Patina also refers to the encrustation of age found on antique artworks. Much of the artistic and monetary value of sculpture is due to the patination. This patination is particularly sensitive to mishandling and to being touched by bare hands.

Some collectors like to caress their bronze sculptures, but with each loving stroke, the monetary value is substantially reduced, and the artistic value will ultimately be erased with the patination. Having a piece repatinated is very costly and gives an old piece a new and

unconvincing surface. Repatination cannot be done successfully on a patch basis; the entire piece must receive the treatment. For example, there once existed in a museum a full-sized cat, a great favorite with the thousands of schoolchildren who visited the museum. Eventually the tip of its nose was touched so many times it was a shiny gold, while the rest of the piece was dark green, the original patinated color. Restoration of the patination cost more than the work's value.

If you have metal sculpture and must handle it, a good solution is to put on rubber dishwashing gloves. The rubber keeps the piece from slipping out of your hands and shields the piece from the treacherous oil on your skin. Thoroughly washing your hands before touching the piece, without protection, will do no good.

STONE SCULPTURE

❑ STONE SCULPTURE IS ALSO VERY SENSITIVE TO YOUR skin oil. When a piece of stone sculpture is damaged by handling, the only method known to remove the damage is to grind the surface down. You can imagine what this does to the quality of the piece. Polished marble is also supersensitive. Most old marble tabletops have long ago been ruined through touching. You may like the dirty, stained, antique look, but it is certainly not what the craftsmen intended when they made such pieces. Again, the way to remove the stain completely is to grind the surface. Spot grinding can be done, but it leaves an infinitesimal dent that thereafter collects atmospheric dirts. Professional conservators may use other techniques — far more costly — for cleaning stone.

WOOD SCULPTURE

❑ SOME WOOD SCULPTURE CAN BE TOUCHED SPARingly with the bare hand if your hands are very clean. Light-colored woods show stains from skin oil. You must be careful about touching wood sculpture because it is also extremely fragile and can very easily split if pressure is applied in the wrong place. However, wood sculpture should be waxed from time to time.

❏ HANDLING AND STORAGE

GESSOED SCULPTURE

❏ Gessoed sculpture is extremely fragile and sensitive to handling. During the seventeenth and eighteenth centuries, painted gesso surfaces were often applied to carved wood sculpture. Such a surface is as fragile as that of any painted picture. These gessoed sculptures should not be touched except to move them. When you move one, grasp it gently but firmly by the base and lean the bulk back against your body. If possible, it would be best to move the sculpture, firmly wedged and cushioned, flat, back side down on a rolling cart.

The best rule to remember with all sculpture: touch only when wearing rubber gloves and only when the piece needs to be moved.

CERAMIC SCULPTURE

❏ Glazed ceramic sculpture is fairly safe to touch with unprotected hands, as with a piece of chinaware. However, if you get it dirty, it's a chore to clean the piece evenly and properly. The piece is very susceptible to breakage during the cleaning process. Unglazed ceramic sculpture should not be touched by unprotected hands because of the high chance of putting a very noticeable fingerprint on it. It is not easy to clean unglazed ceramic sculpture. Such a job is best left to the conservator.

PORCELAIN OBJECTS

❏ *Always pick up small porcelain or other ceramic figurines using two hands.* Never, never pick them up by the head — that is, not if you want to keep them in one piece for any length of time. If you have antique tablewares, don't pick them up by their handles. Most such pieces have been broken at some time and although very skillfully mended, the break may come apart at any time, especially if you depend on the handle to support the weight of the entire piece.

❑ IF YOU ARE FACED WITH THE PROBLEM OF MOVING A piece of sculpture by private automobile and the piece is small (not more than thirty inches high and weighing under fifty pounds) and not especially fragile, get some one-inch-thick foam-rubber sheeting. Carefully wrap the sculpture entirely, making sure that any projecting parts are fully padded. You can secure the rubber sheeting with fabric tape, which will adhere to the rubber. Place the wrapped piece in your vehicle on its flattest side, preferably lying down. If possible, put it on the seat, not on the floor. Block it so it cannot roll or move about, using soft cushions or more foam-rubber padding. In a station-wagon bed, put additional rubber under the piece and block it securely to keep it from moving. If you block it properly, it is not necessary to tie the sculpture into place.

If you are moving a group of sculptures, by using additional foam rubber under and between the pieces, you can use the pieces themselves to wedge each other, but never tightly. Place the heavier pieces so they will not put pressure on the lighter ones. Don't make a double layer.

If you have to ship a work by commercial carrier, you must have a sturdy packing crate made, or you can make it yourself. There are two basic concepts on packing sculpture.

The first basic concept is the old, time-tested method used by most first-class dealers and by museums when they send out traveling-loan shows of sculpture. Build a case fitted for the work at hand. The piece is secured inside the crate by felt-covered wooden elements, which may be hinged, held in slots, held with springs, or wedged with additional felt-covered blocks. Obviously, this kind of complicated crate is normally made by the expert fine-arts packer and is very costly. However, it is also very safe, and if you have a valuable sculpture, especially stone or heavy bronze, this is the best way to pack it. Great care must be taken, however, to ensure that the padded blocks do not rub off delicate patina. Most of the larger museums in big cities can be of assistance in advising you of the packing-crate fabricators available in your area. There are also national art dealers who will undertake such work (see "Services and Products").

The second concept in sculpture packing has come about since the invention of plastic pellets. If you use the pellet method, you need to have a crate made out of three-ply plywood on a frame of 1" by 2" pieces of wood, for a piece of sculpture weighing not more than seventy-five pounds. The 1" by 2" frame is on the outside and serves additionally to provide handles for the shippers (an absolute must with boxes of this size). The box should be at least one foot larger in all dimensions than the size of the sculpture itself.

Wrap the piece in foam rubber (as noted above for private-auto transport). Then fill the crate to a depth of one foot with the plastic pellets. Place the piece upright in the center of the crate, on top of the pellets. Then pour more pellets into the crate, making sure they thoroughly fill all the space around the wrapped sculpture. When the pellets reach the top of the piece, gently rock or wiggle the piece back and forth so the pellets will compact slightly. When the piece can move no more than a fraction of an inch, pour in more pellets, jiggling the box slightly to compact the pellets as you go, until the pellets reach the top of the box. Place the lid on, screw it to the case, and label the case, making sure you use arrows to indicate that the case rides top side up. The box is now ready to go.

The theory is that the pellets will keep the piece from shifting. If the piece is not too heavy, this method should be all right. However, if the piece is fairly heavy, the pellets will compact further under the jars and impacts of shipping. If it ever strikes the side of the crate, the piece could be damaged.

Since the pellets stick to everything and are very difficult to manage, a less messy way is to use four- to six-inch-thick medium to medium-hard foam-rubber lining around the foam-rubber-wrapped sculpture. The slabs of foam rubber must be tightly placed so they cannot possibly shift under even hard impact blows on the case from outside causes and yet not so tight they might damage the sculpture itself.

The secret of shipping any work of art in a packing crate is to pack the work so it won't shift in the crate but will give slightly when under the shock of an impact. The work should be firmly positioned but not rigid. When extremely rare and valuable old-master works are

sent to America from abroad for exhibition purposes, they are very often packed in spring-suspension boxes. These consist of an inner box suspended and supported at each of its eight outer corners by heavy-duty steel springs attached to each of the eight inner corners of the outside box. It is that kind of slight movement, made possible by spring suspension, that you are trying to approximate in your packing.

❑ ANY WORK OF ART WHICH ALSO HAS A USEFUL function belongs in the category of **decorative arts.** Furniture, rugs, chinaware, glassware, metalware, tapestries (originally created to control acoustics and provide weatherproofing), and other objects of this sort belong in the decorative-arts category. Since these objects are what our homes are furnished with, we are familiar with handling, moving, and using them.

However, the more antique and rare a work of decorative art is, the more valuable and fragile it becomes. The tendency, then, is to be afraid of handling the works. Usually we mishandle them because of an overly extreme caution or overfamiliarity. We may forget that a 200-year-old plate was not made to go through the heat of a dishwasher or that a fragile, 150-year-old wineglass was not meant to be thumped to produce a ring. We might even forget that the lustrous patination of old silver adds to its beauty and that dunking such a piece in cleaner to remove all the tarnish will make the design almost invisible (and to regain age-tarnish will take longer, usually, than our own lifetimes).

How, then, does one take care of these objects? Carefully, of course. Use two hands instead of one to lift or move an object. Place an object gently on the shelf. Keep the object in view while you are handling it. Don't lift a piece by the handle, but cradle your hands around it. Don't remove a lid by the knob; using both hands, support the lid from beneath as you lift it. Use similar care on all your collectibles.

HANDLING DECORATIVE ARTS

❑ HANDLING AND STORAGE

CARING FOR TEXTILES

❑ MOST EUROPEAN TAPESTRIES OF THE SEVENTEENTH to nineteenth centuries were made by weaving small sections and then sewing them together to create the whole. These attaching threads, which support greater weight than the woven threads, often deteriorate and allow sections of the taspestry to separate. If you have a tapestry that begins to separate, consult the weavers' guild in your town or those who like to do quilting. They will probably be delighted to help you mend the tapestry or may even do it for you. Your local museum library will probably have books telling what kind of thread was used to sew the sections together and how it was done.

Woolen rugs and tapestries should be mothproofed at least once a year. The Oriental-rug dealer in your community can do this. Mothproofing is necessary if the rug or tapestry is in storage. It is probably a good idea to wrap the object in vinyl sheeting if it is being stored in a cool (below 67 degrees) and dry place. The problem with vinyl is that if the temperature goes above 72 degrees and the humidity rises above 55 percent, mold can grow vigorously if there is little or no circulation of air around the object. At that temperature and humidity, however, you would have mold in any case, on any object, especially if the space is dark.

ANTIQUE DEALERS

❑ BY USING THE RESOURCES AVAILABLE IN YOUR COM-munity, you can save money and have fun while doing so. A good antique shop is an invaluable aid when it comes to finding ways to remedy problems you may be having with your antiques. An antique dealer noted for the quality of the goods she handles normally has a love for antiques that transcends the monetary side of the business. A good dealer not only likes to see antiques kept in the best possible condition, but also likes to know where antiques are located in the community. The good dealer is an excellent resource when you need professional evaluations.

When moving small objects of decorative art by private car, use plenty of loose padding in the container. The most easily obtained padding is newspaper. If you take a double sheet (two pages with a centerfold) and wad it up so it fits into a half-gallon container, you have about the right amount of padding. The wad should be springy when you push on it. Using newspaper padding, you can pack virtually anything of a small, fragile nature. If you want to pack a bowl about a foot in diameter and six inches high, find a cardboard box about eighteen inches square and a foot deep, with a sturdy, solid bottom and good flaps on the top. Wad up (as noted above) enough pieces of newspaper to completely cover the bottom of the box. Nestle the bowl into the wadded paper. Fill the corners with additional wadding and make sure the upper edges of the bowl are protected by the wadding from touching the insides of the box. You may want to put wadding inside the bowl (one wad would be enough). Put further wadding across the box above the bowl to reach the top of the box. Close the flaps and tape them or interlock them.

This method of packing will see almost anything safely through your move by private car. The box can be set carefully on the floor or on the seat, whichever gives extra padding protection.

Remember not to stint on the paper wadding, and don't try to put too many items in one box. Two or more items in one box must be liberally padded from each other. If, when moving the box to test the packing, you hear a clink, you've not used enough padding. It's always better to be too safe than not safe enough.

TRANSPORTING SMALL OBJECTS

Most professional, long-distance, nation-wide moving companies have experts who are adept at packing antiques, if you wish to ship your goods by motorvan or air freight. If you are not moving all your household goods, as in a moving van, the best method of packing a few objects is to use a wooden crate,

SHIPPING ANTIQUES

HANDLING AND STORAGE

constructed much like the one described for sculpture, but adjusted to fit your objects. Long-distance transport requires either foam-rubber or pellet packing. Paper compacts very rapidly into useless little balls which, under the continuous bumping and jolting of highway transport or the severe jolts of air transport (landing, taxiing, etc.), could leave your items in fractured pieces. Do not use shredded paper and excelsior as padding, not only because of the mess, but also because of their high flammability.

SHIPPING TEXTILES

❑ IF YOU HAVE AN ORIENTAL-RUG DEALER IN YOUR community, he is the best source to tell you how to pack a rug or tapestry for shipment. You could probably engage the dealer to pack the item for you.

COMMERCIAL SHIPPERS

❑ TWO-DIMENSIONAL OBJECTS (OBJECTS NORMALLY framed) are packed by the fine-arts-packing experts of the national moving firms. These people use shallow, sturdy cardboard boxes, available in a wide variety of sizes and usually about three or four inches thick. The top of the box fits fully over the bottom so that the vertical element of the top, when closed, is flush with the bottom of the box. Inside, the packers use slotted, corrugated cardboard corner brackets to hold the work(s) away from the edges of the box and firmly in place to prevent shifting. It is quite usual for packers to put more than one framed picture in a single box, if the two works are very close in height and width dimensions. Probably the limit for multiple packing is four works. You can instruct the packers to place the pictures face to face and back to back. This is the safest way to pack in groups, and expert packers do this.

When assembling works to pack or when putting them into storage in your own home, be sure works of similar dimensions are stacked vertically, usually on the narrowest dimension — even if it is not the actual bottom of the picture — in order to save space.

Remember to stack them face to face and back to back. This system keeps screw eyes from accidentally scratching frame-surface finishes. The packer will use a piece of corrugated cardboard between each picture packed face to face. When four pictures of similar dimensions are bundled this way in a single box, make sure the screw eyes of the two back-to-back works do not bind, but are placed in reverse — that is, the bottom face-to-face pair can be laid in the box with their top ends to the left and the upper face-to-face pair with their top ends to the right. This will keep the screw eyes on the two which lie back to back from bumping into each other and causing problems.

MISCELLANEOUS

❑ IF SCULPTURE IS STURDY AND NOT FRAGILE (STONE or metal objects with no projecting elements), it can be packed in the same boxes with pillows or other very soft, padding-type household items. Professional movers are usually your best advisers on methods of packing fine china and glasswares. You shouldn't allow the hassles of moving to worry you when you have an art collection.

It is a good idea to obtain special insurance with the moving company (in addition to your regular personal property and fine-arts policies). This tends to guarantee that the movers take extra care with your possessions. Shipments for long-distance moving are normally so well packed that there is rarely even slight damage, but it is an assurance for the owner to be as safely covered as possible. The charges for such extra insurance are minimal.

A final word regarding professional commercial movers — ask the manager of the company of your choice to provide the most experienced packers employed by the company to pack your art-work. Request that the drivers who will be packing your possessions into the moving van and driving to the final destination be the most experienced persons available. Make sure the movers will provide picture cartons, not mirror cartons, to pack your two-dimensional art. Get an advance written agreement stating the above and any other special arrangements you've requested before the packers arrive.

◆ FOR THE ◆ GALLERY

CHAPTER SEVEN

*Of course I need help . . . I came in here with
a friend and now I can't find her!*

Space Allotment
Commercial Exhibition
Cluster, Not Clutter

◆ FOR THE GALLERY

FOR THE GALLERY

◆ THIS CHAPTER IS INTENDED PRINCIPALLY FOR THE professional exhibitor of artworks: the art dealer, the frame-shop owner, the antique dealer, or anyone who uses art objects for direct sale or as luxury items to promote sales of objects or goods, such as a furniture store or a boutique. The information in this chapter can also be used as a guide by the customer who appreciates a well-run art gallery.

SPACE ALLOTMENT

◆ A CUSTOMER WANTS TO BE ABLE TO SEE A SUFFI-cient range of objects to choose a selection for purchase. However, too many objects and too great a range tend to confuse the customer, making selection difficult if not impossible. A store with too many items encourages the browser and discourages the purchaser.

Many of America's most efficiently operated art museums divide interior spaces into three parts to coincide with the three basic divisions of the museum's operations: exhibition and display, storage and maintenance, and management and research. Calvin J. Good-man, one of America's leading experts on the role of the commercial art gallery in the marketing of art, advises space usage similar to that used by these museums. Space allotment in this manner creates a quiet and orderly business atmosphere, inducing a high level of consumer confidence in the gallery. The area used for exhibition should be as near as possible to the principal entrance of the gallery. Administrative offices and private sales-presentation rooms should be placed beyond the public exhibition area while areas for storage of artwork, work space for display preparation, and equipment storage should be at the back of the store facilities.

COMMERCIAL EXHIBITION

◆ THE PROBLEMS OF ART PRESENTATION CONFRONT-ing the gallery owner are somewhat different from those confronting the museum curator. In the museum, art is presented in a way that, ideally, educates the viewer and increases appreciation of the art. In a

sales gallery, the art must be presented to stimulate the viewer into wanting to own one or more of the pieces on view. An expression you may have heard about a work of art in someone's home is, "Oh, that really belongs in a museum." Examination of the work might reveal that it is not so much the work itself, but the manner of display that suggests a museum.

The gallery should exhibit art as if it were in a home rather than in a museum. We see the beautifully designed display windows in expensive furniture stores. We can hardly wait to rush in and buy everything in one or more windows and recreate the effect at home. Such is the psychology of salesmanship.

The workable solution for the gallery owner is to present art as a decorative adjunct in a living space, as opposed to the museum, which uses space as a necessary adjunct to house art. Although the gallery owner usually wants to increase the customer's appreciation of any given artwork, that is not the principal reason for exhibiting the artwork. The reason is to present in a congenial atmosphere an attractive exhibition conducive to sales. By following the rules and procedures set forth in this handbook for private display of art, the gallery owner will probably find that customers are more receptive to sales tactics.

◆ PROBABLY THE BEST METHOD THE OWNER OF THE small art gallery (2,000 square feet of space for the entire store) can use to display art is the grid arrangement. By creating the grid with the outer and inner edges of the horizontal and vertical elements of frames as well as by the diagonals of opposing frame corners, a widely spaced grid can be made with only a minimal reference to subject matter. Interspersing sculpture and decorative art with pictures projects the grid invitingly into the customer's viewing space.

Since the grid arrangement is a favorite device of interior designers, many gallery customers will be more familiar with the grid than with the more formal, museum, all-pictures-in-a-line approach. The

CLUSTER, NOT CLUTTER

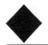

◆ FOR THE GALLERY

Wall pieces stored on sliding racks or metal 4' section shelving. Objects stored in metal cabinets with locking doors.

Gallery art reference library should be in here.

Lavatory

Storage

Sales Finalizing Office

Preparation Area

Business Office

Access Corridor

Wall Display Area

Reception Desk and Telephone Center

Main Gallery Display Area

Wall Display Area

Wall Display Area

Object Display Area

Objects in show window area are seen as special by customer.

former method suggests art a customer can have at home; the latter suggests art owned by a museum and therefore not available for home use. If works are sold off the walls (the usual procedure), replacements of comparable size and subject matter can be immediately put in the vacant spot.

A grid-pattern display produces a friendly, attractive cluster of objects inviting the customer's attention. It should be comprised of a carefully chosen selection of the gallery's inventory. There should be no near duplicates, and there should be enough space between works to allow the viewer to concentrate attention on one work at a time. At all costs you should avoid overcrowding wall or floor space. This produces a messy, cluttered effect that will drive customers away.

If a gallery represents a large number of local artists (as many galleries in small to medium-sized cities do), the use of the leaf- or book-display rack is handy. The rack is comprised of a series of about a dozen five-foot-square wooden panels fastened into metal frames that are, in turn, securely fastened vertically to wall-mounted hinges (as if you were gluing the spine of a book upright to the wall) (fig. 47).

Using standard hooks, the panels can be installed with two-dimensional art on both sides, and a customer can leaf through them. The rack is very strong, and a wide variety of works can be hung without giving a jumbled, cluttered effect. An added benefit to this rack is that, since it is placed at eye level, the pictures in it are all very easy for the customer to see without straining. In an overcrowded, cluttered gallery, many of the pictures are often as much as five or six feet above the customers' eye levels and the pictures are simply not seen.

If you own an art gallery, it is wise to remember that many buyers of art buy on impulse. They find something they like and buy it, then and there. It is easier to see works that are not crowded together but are pleasantly and attractively displayed. The subliminal suggestion, of course, is that the work will look just as nice in the buyer's home.

Book Display Rack

Fig. 47

★ FOR THE ★ COLLECTOR

CHAPTER EIGHT

He was going to give the collection to a museum, but then this architect talked him into building a wing on the house, and one wing led to another . . . and

★ FOR THE COLLECTOR

ART AS INVESTMENT

★ OVER THE PAST DECADE, DISTINGUISHED NEWS sources such as *The New York Times* and *The Wall Street Journal* have printed articles which state that investing in art is perhaps better than investing in stocks and bonds. We've all read of the record-breaking auction prices paid for works of art. In 1984, an oil painting by the English nineteenth-century artist J. M. W. Turner brought more than $10,000,000 at auction. Usually, the sale price established at auction is greatly in excess of the price the original owner actually paid. In the case of the Turner mentioned above, the painting came from the estate of the late Kenneth Clarke, noted English art historian and author of the award-winning television series, *Civilization*. Lord Clarke obtained the Turner many years ago, recognizing it as a superb example of the artist's work, at a fraction of the record-making auction price.

In another example, a small dealer in England paid about $250 for a life-sized marble bust of a pope. He, in turn, sold it for about $350. The man who purchased it later stated that he thought it might be a work by the leading seventeenth-century Italian sculptor, Gianlorenzo Bernini. He loaned the bust to a major London museum where it could be thoroughly examined by experts. The owner, being very interested in art, also did his own research on the work. To date, most of the experts agree that the bust is, indeed, by Bernini. The value, therefore, is not in the $300 range but rather in the $50,000 range.

Although finds like this are extremely rare occurrences, they can happen. Yet how many of us would be so lucky? How many of us have the ability to know what we are actually looking at when we see a given work of art? This is the knowledge of the serious collector. It should be the mainstay of anyone who buys an original work of art.

WHAT TO COLLECT

★ NOBODY HAS SO MUCH KNOWLEDGE THAT HE always knows every work of art being offered on the market, either from the dealer or the auction house. Museums spend years researching their own collections and start with the most genuine art they can

find. Museums rarely buy *problem* art — art that is questionable for any reason — since they are usually paying with trust funds and cannot afford costly errors. The difficulties involved with problem art include the following: unidentified artist, less than good condition, whether the work is genuine or a forgery, whether the title is clear, whether the work is suitable for the collection, and whether the work is by the artist indicated or is a later copy. For an almost endless number of reasons, a work might be questionable.

Those who are daring can sometimes take a chance with a work that is questionable in some way. We may make an error or we may make a wise decision. However, before we purchase we should have at least a strong hunch, based on knowledge, that the work is what we hope it is. Time for full research will tell us what kind of decision we have made.

THE ART PROFESSIONAL

★ BASICALLY, THREE TYPES OF PROFESSIONALS FUNCtion in the arena of art: the art historian, the art dealer, and the art museum. To these can be added the art school, but this area overlaps with the art historian, who provides a principal educational force in the art school.

Like anyone who pursues a professional career, the art historian is a highly trained individual with undergraduate and graduate degrees. He will be trained in cultural history as well as general and specific aspects of art history. Upon graduation, he will be qualified to teach in a college or university, do research and publish his findings for other researchers, work in the curatorial department or other administrative areas in a museum, become a consultant to advise private individuals, museums, or corporations on acquiring art, join the staff of a commercial art gallery or auction house, or go into related work.

Most art historians, at some time in their careers, serve as advisers to collectors. Many do this by teaching courses on how to collect art as part of their duties on the staff of an art museum or art school. Some are employed by a small group of collectors who want to

Clutter has an awful tendency to overwhelm.

assemble major holdings in their fields of interest. Each of these art historians has a wealth of information that can be shared with others.

Although the art historian usually collects art himself, in a small or large way, he is not basically a collector. His main interest lies in the beauty of a given work of art and the culture that created it.

In general, a good art dealer is not an art historian, although he will have trained himself with courses in art history and may have a graduate art-history degree. Because he must understand art marketing, he will also have training and experience in merchandising such a high-priced commodity as good art. The dealer's main interest is to see that the right buyer (consumer) obtains the right piece of art, whether that buyer is a private collector, a public art museum, or a corporation. The art dealer also often forms an excellent, personal collection drawn over the years from his sales inventory.

The art museum has been legally defined as an institution that owns a collection of artwork and displays that collection on a regular basis to educate the public. The curatorial departments of art museums are staffed with persons holding graduate art-history degrees, who are qualified to conduct research on the museums' collections and prepare that research for publication. These curators also usually share their specialized knowledge with local collectors and local art dealers to improve the quality of artwork in the community.

The private collector is not necessarily an art historian. The collector's interests in art are as varied as his or her reasons for owning it. A collector becomes interested in art because of the work's beauty. Art enhances living spaces and provides a special kind of satisfaction. Until recently, collecting good art by major artists was a status symbol of the rich. Understandably, maintaining and insuring a priceless art collection is an expensive undertaking which relatively few can afford. However, since the late 1940s, a growing number of people not in the realm of the very rich have been forming important collections. With the increased number of collectors (art consumers) and with the inflationary period that has been with us since the end of World War II, art prices have spiraled upward at a somewhat alarming rate. Some of those persons new to collecting have become

interested in art as a means of major investing. Nobody starts buying stocks and bonds or real estate without making a full investigation of what is involved and generally obtaining the services of a professional broker to assist. However, when buying art, a great many people start making purchases without any in-depth advance investigation or outside expert advice. Such collectors may be in for a very rude shock when they discover that what they bought was not what they hoped they were buying.

This brings us back to knowing as much as possible about any given work of art before buying it. The knowledge you need includes quality, condition, what the price actually means, dealer guarantee, how to buy at auction, and more broadly, making use of community resources such as your public library, your local art museum, and a qualified local art consultant.

QUALITY

★ QUALITY IN ART IS NOT MERELY A MATTER OF OPINion, although opinion plays an important role. Good quality art will be well composed, very well executed technically, in good condition, suitably well framed or mounted, and will have a sense of timelessness. When placed together, one good piece of art will complement another, regardless of the actual time periods in which each was created. If you, as a collector, have a work of art that is difficult to display with other items in your collection, it is possible that the work is not as good in quality as the other objects. Conversely, the work might also be far better than the other pieces. ***Works of similar quality look good together.***

Some collectors buy only "brand-name" art; they may feel on safer ground with works only by well-known artists. An unsure collector may feel that a knowledgeable visitor would think less of the collection if works by little-known artists are included. If the collector cannot obtain the very best works by his favorite brand-name artists, he can get a collection of extremely uneven quality. The brand-name collectors are, unfortunately, likely to get questionable works foisted off on them from time to time in their zeal to acquire

only works by the "approved" artists. No artist ever produced all masterpieces.

Buying brand names requires a considerable in-depth knowledge of the works of all the artists collected. Such a collector would be served best by 1) engaging the services of an art historian/consultant to assist in determining quality and fair-market value and 2) buying only from trusted dealers who offer a money-back guarantee if the collector is dissatisfied with the purchase.

WHAT THE PRICE MEANS

★ THE ASKING PRICE INDICATES WHAT A DEALER FEELS about the quality of any work of art. Since the dealer is in business to earn an income, you do not normally get bargains on good quality works of art. If you, the collector, know the current auction prices for works by your favorite artists, you have the basis for the fair-market value of the work. **Fair-market value** is the purchase price established by the competitive bidding that takes place during an auction sale.

During the past decade, fair-market value has come to mean an average price derived from the difference between a lower price obtained at auction and a generally higher price obtained by the dealer. On less expensive works by minor artists, fair-market value may include a range of several thousand dollars. On major works by major brand-name artists, fair-market value may range from $50,000 to $100,000. The advance estimates printed in auction sale catalogues are the fair-market-value ranges estimated by an auction house. For example, when a Renoir is estimated at selling for between $350,000 and $400,000, chances are that the painting will sell within that $50,000 range, reaffirming what has probably already been established as a fair-market value for that type of Renoir painting.

A dealer's price is usually somewhat higher than that established at an auction sale. It would seem, therefore, that you would probably get a better bargain if you always bought at auction. However, there are certain drawbacks that cause many collectors considerable hesita-

tion before buying at auction. First, all sales are final, and purchases must be paid for immediately. Second, no auction house guarantees the authenticity of any work; statements to this effect are prominently printed in the sale catalogue. Third, although a cursory examination of a work can be made before a sale, no auction house allows a thorough examination to be made on or off the premises by a qualified conservator.

These three points should suggest to you that you must have a fully professional fund of information on the artist and the work or engage the services of a qualified art historian/consultant to examine the work before you think of buying at auction. The instances of an unidentified work selling for a pittance and afterwards being discovered as a long-lost masterpiece worth millions are very rare. The reason this occurs at all is because the buyer is a highly trained art historian and feels he has recognized the work in advance of the auction sale. Such a buyer would feel safe in risking a small amount of money on a gamble he hopes will pay off.

What you pay the dealer for, in addition to the actual cost of the work, is his guarantee of the work's authenticity, the information his research has uncovered about the work (the information is included with the bill of sale), an opportunity to have the work carefully examined at a conservation studio, and if needed, permission to pay for the work in installments. The good dealer knows that the work he sells is worth the price he asks.

As you become fully aware of the ramifications of art-price structuring, you may occasionally find a work priced far too low. About the only place this can happen legitimately is at a local estate sale, not at an auction. It occurs because of ignorance of the correct fair-market value on the part of those responsible for pricing items for the sale. A good many bargains can be found at estate sales. If the low-priced work is at a dealer's and is not being sold on consignment but from the dealer's inventory, you will know immediately that the dealer thinks the work is questionable. This work is not a bargain, and you should stay clear of it.

DEALER GUARANTEES

★ A GOOD DEALER STANDS BEHIND THE QUALITY OF the work he sells. If a dealer tells you he makes no guarantee of the authenticity of the art he is attempting to sell you, don't buy. Most dealers have some sort of arrangement to refund your entire purchase money if, within a year, you wish to return the work because you are dissatisfied with it. Some dealers will allow you the current market value on works previously acquired from them if you wish to trade that work in on a more expensive one. These dealers know that what they've sold is worth the price they sold it for, and unless there is a serious decline in world art prices, these values hold.

TOP-OF-THE-MARKET PRICES

★ MANY COLLECTORS PAY A PREMIUM PRICE FOR THE work of an artist who is currently popular. This means they are buying art at **top-of-the-market prices.** Collectors often want the most fashionable art of the moment and are willing to pay for it. Major traveling exhibitions presented by the nation's top museums usually cause a dramatic upward jump in prices of works by the artists included in these shows. Over the past several decades, paintings, drawings, and graphics by the nineteenth-century French Impressionists have commanded top dollar in the art market, reflecting a number of major exhibitions devoted to these artists.

Most museums rarely buy top-of-the-market art, partly because their funds are severely limited and partly because curators know that when the current vogue is past, prices will decline. A wise collector will follow the museums' lead and buy works by less fashionable artists. However, it may be a moot point to remember that whereas museums may have a century to acquire the works they most want at the prices they feel they can afford, most collectors form their collections and keep them usually from ten to thirty years.

It is better not to buy at top-of-the-market prices because an artist's popularity is generally fairly short-lived. When the fad passes, the prices decline. Twenty-five years ago, most works by the American painter John Singer Sargent could be bought for under $1,000. In 1979-80, there was a major Sargent international exhibition.

Recently a portrait by the artist sold at a New York auction house for $250,000, and it is not presently possible to buy a good Sargent painting for under $100,000.

It is a good idea to watch the price fluctuations obtained at auction to determine whether an art fad is in operation regarding a specific artist or artistic school. *ARTnews Magazine* publishes a biweekly bulletin called *ARTnewsletter*, which keeps its readers informed on the latest auction and other sales action throughout the world. This and similar publications (see "Selected Readings") are extremely helpful to the collector.

BUYING AT AUCTION

★ SINCE I'VE PREVIOUSLY DISCUSSED SOME OF THE drawbacks and benefits of buying at auction, it seems appropriate to note some tips about buying at auction. First, however, you should understand the various classifications of auction houses and what kind of art they handle.

New York City is the leading art center in North America. The world's premier auction firms have salesrooms in New York. The big two, Sotheby's and Christie's, each do a multimillion-dollar business selling art in this country, although both firms are headquartered in England. They sell virtually every kind of collectible from paintings and sculpture to furniture, rare books, and jewelry. They even sell vintage automobiles, wines, and real estate. With the exception of the real estate, everything is sold by competitive bidding. The other two major auction firms in New York are Phillips and Doyles. These two smaller firms concentrate on less important art. Selling in New York gives you the broadest market while buying pits you against the most informed competitors.

Outside New York, a number of regional auction firms are located in New England, Washington, D. C., Detroit, Chicago, and San Francisco. These regional firms have regularly scheduled sales throughout the year. Additionally, there are once-a-year auctions of major, western-oriented works held in Houston and Oklahoma City.

Local auction firms may include art objects in addition to other

types of goods. Local, regional, and national firms may also conduct estate auctions on a one-time-only basis anywhere across the country.

New York's auction houses probably get the highest overall prices because they sell the best quality art. However, if you buy western art in the Houston art and livestock auction, you can expect to pay top-of-the-market prices because western art is currently fashionable, especially in Houston. A little time spent in your local library will identify the in-vogue art in the various parts of the country, and thus what you can expect to pay (or, if selling, receive) the highest prices for.

An informed collector can do very well buying artworks at reputable local or big-city auction houses. Some tips on buying at auction are listed below:

1) Attend several auctions before doing any bidding in order to get the feel of buying at auction, how the auctioneer handles bids, and how to pace your own bidding. You might even note the best location to sit in the auction room.

2) Before the sale or before you bid on anything, be sure you read and understand the conditions and terms of sale, which are usually printed in the front of the sale catalogue.

3) Never bid on anything you have not personally examined. Keep written notes on the condition of the work and any damage observed prior to the sale. A friendly witness may be useful.

4) Determine your price limit beforehand and never go above it, even if someone else gets the item. Auction fever is real, contagious, and financially unhealthy. With reputable auction houses, written or *table* bids made prior to the sale can be good preventive medicine.

EXPAND YOUR KNOWLEDGE

★ AS A COLLECTOR, IF YOU WANT TO EXPAND YOUR knowledge of your favorite art, there are a number of things you can do. The simplest and most convenient thing is to read a good, well-written, and well-illustrated book on your artist or period of art. The text must be informative and scholarly. Most of the coffee-table variety of beautifully illustrated art books contain popularized, not

scholarly, texts. A good art textbook usually has more illustrations in black and white than in color. This is partly because of the expense of printing color plates, but it is also because the color-plate printing does not reproduce colors with the fidelity and accuracy needed, and therefore black-and-white reproductions serve better.

Read more than one book on your subject, by more than one author. You need more than one set of opinions. If you particularly like the work of just one artist, read enough books so you can recognize your artist's hand in all the media he used.

Picasso, for instance, was a painter, sculptor, ceramist, draftsman, printmaker, and designer. Having such a long professional career, he also worked in a number of styles. To have a study library on Picasso would require having a general book on his overall life and work, then specific books on his painting, sculpture, printmaking, drawing, etc. You would also want general books on late nineteenth-century Spanish and French art, turn-of-the-century French art, cubist art, 1920s neoclassicism, and avant-garde French art from the 1920s through the 1970s. You would then have at your fingertips enough study material to truly know Picasso's work at any given period. Most artists, unfortunately, are not so well covered by published works.

If this kind of thorough reading program is not enough for you, take courses at your local university art department. The faculty will usually take special interest in an avowed collector and can be of great assistance in suggesting the proper courses to take. These courses can be audited (taken for no credit) or taken for credit on a special student basis or in a degree program.

In addition to going back to school, you can attend lectures given in your community by local experts and visiting scholars. Your local art museum is an excellent resource for information on these programs. Through the public television and public radio networks across the country, you also have access to important discussions of current projects and problems in the art world. The programs are usually more general than specific, but they offer such a wide range of subjects that quite often your special interest is covered.

An enormous number (approximately 300) of art magazines are

published throughout the world. Most are printed in English or have English editions. They range from the glossy, expensive variety — which are related in the quality of texts and illustrations to the typical, coffee-table books — to the scholarly, hairsplitting magazines so loved by art historians. A good community or university library art-reference department can compile a list of these periodicals for a small charge.

A collector who wishes to know more, even beyond his chosen area of concentration, assembles a good, overall art library. Well-written and well-illustrated books are available from most any good book dealer. You can also obtain excellent reference books as well as picture books from the several remainder-book outlets which sell books at great discounts by mail. Art books don't really go out of date, although new research continually updates information on any given artist or style. Older, out-of-print books, which can be obtained from used-book stores, may cost a bit more, but are usually worth the price. Several general art encyclopedias are published in English, as well as excellent ones in French and German. The exhibition catalogues published by museums and art dealers across the country provide a major source for information on often little-known aspects of art history.

Finally, major and minor auction houses publish catalogues of their sales. Auction catalogues furnish a wealth of information. In addition to the artist's name, an entry often includes the artist's life dates, a photograph of the work being sold, the opinion of the auction firm's research staff on the work's authenticity (indicated by the manner in which the artist's name is printed — information at the front of the catalogue explains this), the ownership and exhibition record of the work, published information on the work, and the estimated fair-market value. Many auction firms will send catalogue subscribers a list after the sale, noting the actual price paid for each lot.

CHAPTER 8 ★

SUMMARY

★ AS A COLLECTOR, WHETHER YOU OWN A FEW PIECES or many, have just begun or are well established, are still deciding what to collect or know exactly what you want, it benefits you to know as much as possible about what you collect. It is also helpful to keep records on your collection and, above all, to know how to show your art safely and effectively.

 # GLOSSARY

GLOSSARY

✤ The words and phrases listed below are either specialized art terms or have specialized meanings in this handbook. They are arranged in alphabetical order.

Acid-Free Paper is paper or a paperboard product manufactured by hand or by machine wherein the acidic content of the cellulose fibers used to form the paper has been neutralized by the addition of an alkaline substance. The degree or measurement of acidity in the paper is called the *pH factor*.

The pH or acidity-base factor is neutral at 7.0, completely acid at 0.0, and completely acid-free at 14.0. Paper is considered acid-free if the pH factor is 7.0 or above. Commercially produced acid-free paper is usually in the range of pH 7.0 to pH 8.3. Paper made with cloth fibers is commercially acid-free whereas paper made with wood pulp is not. The cloth content gives the terms *rag mat* or *rag board* to acid-free paper board.

Appraisal is normally used to describe the monetary value of a work of art. One gets an appraisal from an appraiser, dealer, auction house, or other qualified source. An appraisal may also mean an artistic evaluation of the given work.

Another word for appraisal is *valuation*. The difference between valuation and *evaluation* is that the former is based on factual data and the latter is based on opinion and experiential data. An artistic evaluation, therefore, would not include a monetary valuation or appraisal.

Area Shading, in two-dimensional art, refers to an area that has been shaded so as to give the illusion of three-dimensionality through the suggestion that there are shadows or shading cast by another element that projects forward, occluding light from it. The word is most often used in reference to drawings or graphics where tones of gray, black, and white are used instead of color.

Arrangement denotes the pattern created by placing various works of art together for display purposes.

Art has been used to designate certain branches of learning as opposed to the natural sciences since the time of the early Greeks, who categorized much of the learning we follow today. In this sense, art includes fine arts (drawing, painting, sculpture, and graphics), ceramics, architecture, music, literature, drama, mathematics, and dance. Since the nineteenth century, those objects that have a useful function in addition to their art value, such as furniture, china and metal wares, rugs, tapestries, glassware, and book bindings, have been called *decorative arts*. In this book, art is used to mean the fine arts and the decorative arts.

Art Consultant refers to an expert on matters pertaining to art, qualified through education, experience, and knowledge. The art consultant is almost certainly an art historian. He may also be an appraiser. He will know when an object needs conservation, but he will not normally be a conservator. He could also be an expert in layout design. Although he will have an area or period of specialization in art, he will have a broad, general knowledge of all art. He is the detective and lawyer of the art world.

Average Eye Level is a horizontal band or zone, about 15 to 24 inches thick, top to bottom, wherein falls the direct, focused view of the majority of people when they look straight in front of them. If the majority of people will be standing in a certain area, the average eye-level zone will be higher than if they will mostly be sitting (see "Eye Level"). When using a centerline display, the centerline should be located halfway between the top and the bottom of the average eye-level zone (see "Centerline").

Centerline is the horizontal line halfway between the top and the bottom of a picture or other work of art. It is determined by measuring the height of the picture frame at its greatest point and dividing the figure in half. If one is making a group arrangement using the centerline system of design, the centerline should bisect the entire arrangement.

Chemical Burning occurs as sulfurous acid is released from non-acid-free (wood-pulp) paper. The acid causes the paper to turn brown and become dry and brittle. Chemical burning also attacks acid-free paper when it is placed next to non-acid-free paper.

Cluster Arrangement is a type of display design that gives the effect of haphazard clutter but has been carefully calculated and measured to produce a highly informal effect. It is actually an

118

incomplete grid arrangement (see "Grid Pattern Arrangement").

Clutter is a haphazard arrangement that has not been planned. It tends to minimize any true quality or value of the art. It overwhelms the viewer and is extremely uncomfortable to confront. It is produced by simply sticking works up on a wall without any plan.

Color denotes the property of reflecting light waves of a particular length. The primary colors of the light spectrum are red, orange, yellow, green, blue, indigo, and violet. In fine arts, there are three primary colors: red, yellow, and blue, which, when mixed in various ways, produce the secondary colors, green, orange, and purple. All other colors are simply further variations. Black, white, and gray are often called achromatic colors, although black is caused by the complete absorption of light rays, white by the reflection of all rays that produce color, and gray by the imperfect absorption of all these rays. We refer to black as the absence of all color, white as the presence of all color, and gray as the mixture of black and white. Obviously the black pigment is not true scientific black, or we couldn't see it; it is actually an exceedingly dark gray.

Color Intensity refers to the amount of dilution from full strength of a given color. Full intensity is pure-tone color with no dilution.

Color Wheel refers to a circular design arranged to place the primary and secondary colors in correct relationship with each other. Relating it to a clock dial, yellow is at 12, green at 2, blue at 4, purple at 6, red at 8, and orange at 10 (see "Complementary Colors," "Primary Colors," and "Secondary Colors").

Complementary Colors are the colors opposite each other on the color wheel. Yellow and purple are complements, as are green and red or blue and orange.

Composition basically refers to the design in which the artist arranges the subject matter of a given work of art. It can be expanded to mean the design created by a person arranging a display of artwork.

Compositional Balance occurs when an artist designs his subject matter so that there is no stress in any one direction, or when there are such stresses, they are balanced by other stresses in contrasting directions. Such a design is not necessarily symmetrical although it could be.

Compositional Direction occurs when the artist's composition has a distinct directional flow to one side or another or towards the top or the bottom. Directional flows in opposition create balance, but directional flow or stress toward top and one side would create a compositional direction toward the top and that side. Compositional direction tends to cause the viewer to look or to follow the direction indicated. This is done subliminally, and probably neither the artist nor the viewer is consciously aware of it, although the alerted viewer can spot it immediately.

Compositional Solid refers to an area in the artist's design that is seen as a solid, heavy block. A small compositional solid will balance a large compositional void. For example, a small area of black, dark blue, or full-intensity red will balance larger areas of yellow, white, light blue, or green.

Compositional Void is an area in an artist's design that takes on an appearance of emptiness, vacancy, or transparency. It tends to form a hole through the picture. If in a sculpture or other three-dimensional piece, such an area might be the space between the body of a figure and the elbow when the hand rests on the hip or the space between the legs. It is a necessary part of the composition used to define the shape.

Conservator is the name or title of a person who repairs damages to artworks. The usage of this term has come into existence chiefly since the mid-twentieth century. The former term was *restorer*, but this name has the unfortunate suggestion that the person can repair any errors he might make, while *conservator* suggests that the person is primarily concerned with conserving everything that the artist originally created.

A conservator is a highly trained art professional and usually has degrees in art history as well as chemistry. The conservator normally works in a museum and certainly for a museum. Because formal training for the conservator is a fairly recent occurrence, there are still many older people who, although very efficient, did not receive this new, extremely specialized training. There are still others who learned to restore art because there was no one else around to do the job. In order to establish and maintain criteria for the highest level of workmanship in this field, a national organization for conservators was formed in 1973, the American Institute for Conservation of Historic and Artistic Works.

Counterdirection is the use of one or more works with compositional direction opposite to that of preceding works used in a display. Counterdirection means to reverse the directional flow and thus retain the viewer's interest.

Decorative Arts are works of art which have a primary function or use in addition to their artistic ornamentation (see "Art" and "Fine Arts").

Degree of Gray Value refers to the heaviness or lightness of the use of gray lines or areas in a black, gray, and white (monochromatic or achromatic) work of art. A delicate outline drawing has a small degree of gray value when compared to a drawing that has broad swaths of black and gray area shading.

Depth of Field is a phrase that has become

familiar through the photographic medium. It means the creation of the illusion of space within a two-dimensional plane. A landscape with tiny buildings, which seem far away on the horizon line, has a greater depth of field than a still life with fruit on a tabletop placed in front of a drapery.

Direction/Counterdirection refers to the use of two or more works that have opposing compositional flow or direction. The best way of leading a viewer into a group arrangement is to place inward-directed works at the outer edges. Taken by themselves, without any other works, you would have direction/counterdirection. When used with other so-designed works as well as with balanced compositions at or near the center of the arrangement, you have a display that fascinates the viewer.

Display is synonymous with arrangement or exhibit. It can be a single piece or a group of artworks that have been arranged to show off the art at its very best.

Display Intent is the reasoning behind the purpose of a display. Most works of art are displayed to decorate an area, to show the quality of the works, or for both reasons. In a sales gallery, an additional intent is that of inviting sales. Some displays are made solely to educate the viewer, as in a museum educational situation. Some displays are meant only to inform, and other displays are designed to subliminally induce confidence in the viewer toward the person or organization showing the art.

The intent of display is paramount in the manner which is employed to arrange the art. If one intent is desired and the arrangement contradicts or minimizes the intent, the display is a loss.

Documentary Card is a small file card used to record pertinent information about a work of art. It documents the work of art.

Documentary Folder is a legal-sized folder, preferably in acid-free paper stock, used to hold all the records relating to a specific work of art. The records are clipped into the right side of the folder and an acid-free photo envelope is stapled to the left side. It is best to use a two-hole punch and two-hole fasteners to hold the records that are clipped into the folder.

Documentary Information Sheet refers to a listing of all the pertinent information regarding a specific work of art. The sheet is part of the text under recordkeeping. It is clipped to the top of the stack of other information one puts in a documentary file folder.

Documentary Photograph is an 8″ by 10″ black-and-white glossy photograph of a given, specific work of art used to make a photographic record for file and insurance purposes. The documentary photograph should show the entire work, not a detail or not nearly all of it, but all of it. Black-and-white photographs are more permanent and accurate than color photographs.

Double Hanging places two pictures or other wall-hung artworks one above the other in an arrangement or by themselves.

Dramatic Effect is the use of a single work of art displayed to enhance its potential drama. Because it immediately draws strong attention from a viewer, it should be a work of unusual quality and rarity.

Dynamic Symmetry describes a system of design based on observation of nature but scientifically and mathematically evolved. The system was created by Jay Hambidge in the early years of the twentieth century and used until just after midcentury as a means of teaching composition to art students throughout America (see "Golden-Mean Section").

Evaluation is the summarization of opinions regarding a work of art for the purpose of forming a judgment of it. An evaluation made by an expert is more reliable than one made by an amateur. The opinions may be backed up by factual data but, in itself, the evaluation is not factual.

Exhibit is a display or arrangement of works of art assembled for viewing. The term *exhibition* is perhaps better grammar, but that word suffers from its connotation of being used in museums and expositions and seems a bit grand.

Eye Level is the horizontal line directly in front of a person where his or her view focuses easily. It is actually slightly below the true level of the eyes by about six inches if the viewer stands or sits more than three feet away from the wall. However, depending on the upward tilt of the head while sitting, the eye level may be on the true level of the eyes of the viewer. Works of art displayed on or near this level are most easily and comfortably seen by the viewer and therefore are the most successful displays.

Fine Arts is the branch of learning that includes painting, sculpture, drawing, graphics, and sometimes architecture. The ancient Greeks, during the classical age of the fifth and fourth centuries B. C., evolved this definition, and it was reaffirmed during the Renaissance in Italy, spreading throughout the civilized world from there. Fine arts is defined as the creation of an object that is employed and appreciated for itself alone, with no other function. Because of this definition, the purists say that architecture, which certainly has a function other than being merely ornamental, is not to be categorized within the fine arts, but rather as a major art in itself, such as music, mathematics, and literature (see "Art").

Flush-Edge Placement refers to the placement of framed works of art of identical, similar, or varying sizes so that either their bottom or top edges are aligned with each other. This arrange-

ment is highly arbitrary, and the emphasis falls not on the works themselves, but on the pattern of the arrangement. If one had poor or low quality art to display and wanted the best possible effect, flush-edge placement would be ideal. The exception to avoiding flush-edge placement is when one is hanging a related group, such as a series, a pair, or a set, and the emphasis is not on the individual works but on the relationship between the works; in this instance, flush-edge placement is the most desirable method of arrangement.

Fome-Cor® is a patented name applied to inert plastic foam sheeting, manufactured by Monsanto, used to back glazed works in frames or used as backing behind the stretchers supporting oil or acrylic paintings. The Fome-Cor® sheet is usually one-fourth inch thick and can be obtained in sheets up to four-by-eight-feet in size. The advantage of Fome-Cor® over standard cardboard is that it is composed of a cellular structure sandwiched between two thin, smooth sheets of plastic foam. This allows the sheet to breathe, that is, it allows for slight passage of air, thus reducing the chance of mold forming under adverse conditions. Being plastic, Fome-Cor® is acid-free. When compared to acid-free paperboard used for backing, Fome-Cor® is sturdier, somewhat less expensive, and has the breathing quality the paperboard lacks. Backings are necessary on glazed works and desirable on stretchers for the protection they give on the reverse side of the work.

Footcandle is a unit for measuring illumination. It is equal to the amount of direct light thrown by one international candle on a surface one foot away. Most photographic light meters measure in footcandles. Artworks, including tapestries, Oriental rugs, and other fabric dyes, with pigments that are overly sensitive to the deteriorating effects of light should be illuminated by no more than 10 footcandles. Watercolors should

be lit with no more than 25 to 35 footcandles, depending upon the delicacy of coloring, while oil and acrylic paintings will begin to bleach under lighting in excess of 60 footcandles. Indirect sunlight flooding a room through mesh curtains usually measures from 150 to 500 footcandles, and direct sunlight at zenith, falling straight onto a work of art, will measure up to 6,740 footcandles. Through the nineteenth century, one of the restorer's methods of lightening age-darkened oil paintings was to expose them to direct sunlight for two or three days. Unfortunately, this method is still used by some amateur restorers.

Formal Arrangement is a display that has the intent of creating a formal atmosphere in the area where it is placed. Good quality art tends to become more formal than art of secondary quality. The grid pattern arrangement and the dramatic effect arrangement produce the greatest degree of formality in displaying art.

Foxing occurs when small, light brown spots appear in a painting or other artwork done on paper. Foxing is caused by rusting iron particles embedded in the paper.

Fugitive refers to an impermanent dye pigment. Before the present scientific manufacture of artists' colors, many colors were made from substances not conducive to permanence. Vegetable dyes, coal tar dyes, and some early twentieth-century synthetic dyes are basically fugitive. Unfortunately, the color change is permanent and cannot be reversed. Fugitive colors are particularly susceptible to damage from indirect and direct sunlight, as well as from overly bright artificial illumination (see "Footcandle").

Gesso is a dense and brilliantly white ground that is applied to wood or other rigidly composed panels in preparation to painting in egg tempera, egg emulsion, oil glaze, or oil media.

Gesso is composed of animal-hide glue mixed with chalk or gypsum. It is applied in several layers, each of which is sanded or ground fine before the application of the next layer.

There are usually two or more types of gesso employed in the preparation of one panel: *gesso grosso* is applied in several layers over a wood panel that has been painted with glue (size). Then ten or more coats of *gesso sottile* are applied, each sanded between applications. *Gesso sottile* is made of plaster of Paris that has been slaked in water for a month to reduce its absorbency rate. *Gesso duro* is a heavier, more durable form of gesso used for statuettes and bas reliefs as well as for picture frames and carved furniture. It is then covered with metal leaf, such as gold or silver, or is painted to resemble terra cotta.

During the late Middle Ages, Renaissance, and Baroque periods (fourteenth through early eighteenth centuries), it was customary to coat wooden sculpture with gesso, then paint it. Old works, treated with a gesso ground, are extremely fragile and likely to chip with mishandling. When you see chips of white showing through an old, gilded picture frame, you are looking at the gesso ground.

Glassine is a thin, translucent sheet of cellophane, which is inert. It is about the same thickness as waxed paper, but is fairly stiff. It is used to layer between prints and drawings in a storage situation.

Golden-Mean Section is a name revived by Jay Hambidge to denote the specific peculiarities of partitioning a rectangle so that the ratio of each diminishing section remains constant. This is part of Hambidge's study called *Dynamic Symmetry.*

Graphics/Graphic Art traditionally and historically referred to black and white drawings and prints — that is, wood-block prints, engravings,

etchings, and lithographs. With nineteenth- and twentieth-century developments in printing techniques, however, graphic arts has been expanded to include any black and white or color work which is created by an artist with the intention that it be hand printed to produce multiple copies. *Print* and *original print* are the designations normally used by dealers and museums to denote the printed image, usually on paper, made from woodblocks, linoleum blocks, engraved copper or steel plates (reproducing the effect of a line drawing), etched copper plates (reproducing the effect of a pen, brush, and ink drawing), lithograph (reproducing the effect of a pencil drawing or an ink-wash drawing), and serigraphs, to name the chief graphic media.

Remember that the image was created by the artist with the specific intent that the image be printed. A graphic work of art or print should not be confused with a commercial reproduction. This latter term is used to denote any work of art duplicated by mechanical means rather than being hand printed. Mechanical reproduction, such as offset lithography printed from zinc or gelatin plates, does not have the sensitivity produced by an original print. Reproductions often duplicate works that were not originally intended by the artist to be duplicated, such as paintings, watercolors, and drawings, and the artist's original intention is thereby lost in the reproduction.

Grid Pattern Arrangement is the creation of a group display in such a manner that all of the horizontals, verticals, and diagonals of the framing material are visually interlocked, and the major horizontals, verticals, diagonals, and curvilinear lines of the compositions of the works of art are also incorporated into the visual interlocking. Once assembled correctly, the design cannot be altered without disrupting the whole. Although very complex, it establishes the most

satisfying type of pattern for the viewer. It is the method employed in furniture and wall treatment arrangements by most good interior designers.

Group Arrangement is the display of two or more works of art to be viewed as a unit. In a group arrangement, it is necessary to keep some sort of unifying element apparent, such as similarity of subject matter, medium, artistic school, or artistic period, so that the arrangement does not become simply clutter.

Grouping refers to assembling works that have something in common for display purposes.

Hang means putting up or installing a work of art in a display, as "to hang an exhibition."

Hanging Rod refers to a device that enables one to hang works of art on a wall without piercing the wall with a nail. It is designed to hang from a molding or other projection at the top of the wall. It is equipped with one or more hooked, movable clamps, which can be positioned anywhere along its length and over which is placed the wire supporting the work.

Impact Interest is the degree of eye-catching effectiveness produced by the positioning of a work of art in a display. Impact interest is related to *dramatic effect* but is not synonymous with it. A sculpture placed in the midst of an arrangement of framed works would have automatic impact interest because of the difference of dimensionality. A work with impact interest normally is one with good or high quality. Impact interest communicates itself strongly to the viewer.

Impasto is a word of Italian origin that denotes the thickness of paint applied on a canvas or panel. If the paint stands up in humps so that the mark of the brush bristles can be easily seen in the paint surface, it is said to be thickly or heavily impasted. A work with heavy impasto is

susceptible to extensive paint film cracking, thus making the picture more fragile than its seemingly sturdy appearance would indicate. Pressure impacts from the reverse side on such a work are particularly harmful.

Inert means the chemical neutrality of the state of a substance. Mylar plastic wrapping material is inert as far as any chemical reaction with a painted or drawn surface is concerned.

Install is the verb form of the act of hanging or placing a work of art on display. *Installation* refers to the finished display.

Line Drawing refers to a drawing composed entirely of line work with no shading. There are three basic line drawing techniques: outline, where only the outermost edge of a shape is delineated; contour, where the outer edges and all inner surface planes are delineated in a continuous, connected line; and a combination of the two, in which the inner and outer surface planes are outlined, but the lines are not connected with each other.

Line drawing is usually very delicate and pale because the artist has used a fine-point pencil or pen nib. However, if the artist has used a wide brush and dark ink or has drawn with dark chalk, the line drawing can be very strong and even visually aggressive. Line drawing also describes the effect to be found in wood-block, engraved, etched, or lithographic prints, if they are produced as described above.

Local Color describes areas of color that are not the predominant color in a work. For example, in a still life that is predominantly blue but contains small touches of red, pink, yellow, and green, the small patches of color other than blue would be called local color. Local color is also used to describe colors that, when viewed close up, are bright but when seen from a distance, fade into a general, overall gray tonality.

Medium means the material or substance used

to create a work of art. Actually, it is the visible surface that is the work of art. For example, in painting the medium can be oil, transparent watercolor, egg tempera, or any number of other paint substances or mixtures. In a piece of cast bronze sculpture, the medium is bronze even though one knows the piece was cast in a mold. It is the material of the finished work of art.

Monochrome refers to a work of art painted primarily in just one color; the use of one basic color in a work of art. Monochrome is used in contrast with *polychrome*, the use of many colors, and in contrast with *achromatic*, the use of no colors but rather black, gray, and white.

Multiple Hanging means placing three or more works of art in an arrangement or display, usually in a vertical stack pattern. It also refers to a group of works hung on the wall in more than two horizontal rows, either symmetrically or asymmetrically.

Museum Fatigue is the muscular strain experienced by a viewer when works of art are displayed even slightly above the normal eye level. This phenomenon happens a short time after a person has started looking at art where the centerline (and usually, therefore, the center of interest in the work) is higher than the person's eye level. The fatigue is caused by having to push the head back, putting a strain on a person's neck, shoulders, chest, back, abdominal, and leg muscles. (It is much easier to lean forward to view a work of art than to lean backward.) This is one of the major reasons why people are uncomfortable in many museums. Poor lighting, noise, and uncomfortable climate also contribute, but the muscular strain is the major factor.

Negative Space is a void or empty space incorporated within the overall shape of a work of art, necessary to define the real or illusionary form of the subject matter (see "Compositional Void").

Patina, in sculpture, is the surface treatment. On metal sculpture, this treatment is normally a chemical coating that changes the natural reddish-golden color of bronze to dark green, brown, or black. Patina also describes the encrustation of age damage to metal or other materials. Age patination on furniture is a desirable effect. The chemical patination applied to bronze sculpture is intended to simulate the effect of age patination.

Patination refers to the completed surface treatment on a piece of sculpture or furniture produced either naturally through aging or artificially.

Picture Hook is a patented device designed to allow the use of a smaller nail to safely support a wall-hung work of art. The picture hook, which is available in several different sizes, directs its weight-load into the wall and then down, rather than just down as does a nail without a picture hook. The plain nail is not as secure when loaded because it tends to direct the weight-load slightly outward, away from the wall.

Picture Wire refers to the wire, attached to screw eyes on the reverse of a framed work of art, which holds the weight of the framed work when hung on the wall. In order to get wire strong enough to support the weight, one can test the wire already attached to the picture by lifting the picture slightly off the floor or table and then increasing the weight pressure. If the wire holds, it is probably strong enough to support the picture, even if the picture is accidentally pulled downward after being placed in position on the wall. If the wire snaps during the test, it won't be strong enough to hold the picture indefinitely under vibration or accidental touching. The strongest picture wire is braided steel.

Placement is the position occupied by a work of art in a display arrangement.

pH Factor means *potential of hydrogen factor* which is used to indicate the measurement of acidity in a substance. It is used to determine the acid or acid-free content of paper. On a scale of 0 to 14, a pH factor of 7.0 or above indicates neutral acid content, and paper of that pH factor is considered acid-free (see "Acid-Free Paper").

Pressure Dent means a slight depression or bulge which indicates that a painted canvas or a work on paper has been damaged by something pressed into it. If the pressure dent is bulged outward when viewed from the front, the pressure dent was made from the reverse side; if it is dented inward when viewed from the front, it indicates that the pressure came from the front side.

The chief causes of pressure dents are 1) a jabbing touch of one's finger against the surface; 2) leaning a painting, either face in or face out, against the corner of a piece of furniture; 3) stretcher keys, tacks, or other foreign matter which have fallen into the space between the reverse side of the canvas and the inner front of the stretcher; 4) allowing one's fingers to touch the canvas when lifting or carrying a painting; 5) picking up a work on paper by using only one hand and thus causing a denting crease to form on the surface. The repair of damages caused by pressure dents is usually quite expensive.

Primary Colors are the three basic artists' colors — red, yellow, and blue — from which all other colors are made. Primary colors cannot be made by mixing colors; secondary colors are made by mixing two primary colors (see "Color Wheel").

Provenance refers to the record of previous ownership of a work of art.

Rhythmic Flow is an undulating pattern caused by varied relationships between works of art arranged in a display. A rhythmic flow is a highly

desirable effect to attain since it captures and holds the viewer's attention and enables him to better examine the quality of the art.

Rhythmic Placement means creating a display designed with rhythmic flow (see "Rhythmic Flow").

S Hook refers to a patented hook in the form of an *S* when viewed from the side. It is designed to hang from a wall molding near the ceiling of an interior space and to support a wire secured to its bottom end, which, in turn, supports a picture.

Screw Eye means a screw, the head of which is an eye or loop, used by picture framers to secure picture wire to the reverse of a framed work of art.

Sculpture, Full Round, is a piece of three-dimensional fine art that is finished on all four sides and is meant to be viewed from any angle, although the artist usually designates one side as the front. It is best to display a piece of full-round sculpture so that it may be viewed from any side, that is, out into the space of a room rather than against a wall.

Sculpture, Relief, is a piece of three-dimensional fine art that is not finished on the back side and may, therefore, be displayed against a wall. Further, a relief sculpture is usually designed so that the main subject matter is raised in relief from a carved background.

One often sees the terms *bas relief* (low relief) or *haut relief* (high relief) used in dealer catalogues and art books. These French terms mean that the depth of the surface from the background is either low or high.

Sculpture Base refers to the bottom element or small stand placed beneath a sculpture. It is almost never designed as part of the artistic quality of the sculpture and is not always put there by the artist. Sculpture bases are usually wood or stone, marble for instance, regardless of the material of the sculpture itself and are often screwed to the bottom side of the sculpture. A thin layer of felt is normally glued to the bottom side of the sculpture base.

Sculpture Pedestal refers to a rectangular or cylindrical box, usually about three or four feet tall, used to support a sculpture on its sculpture base. Most sculpture pedestals are modern and simply designed, but occasionally one needs an antique or period pedestal to support certain sculptures in the most effective manner. For this purpose, one can obtain elaborate and complex pedestals of carved, gilded, and painted wood or carved marble from an antique dealer.

Secondary Colors are all artists' colors other than the primary colors (pure red, yellow, and blue). Secondary colors are made by mixing the primary colors. The chief secondary colors are orange, made by mixing red and yellow; green, made by mixing yellow and blue; and purple, made by mixing blue and red (see "Color Wheel" and "Primary Colors").

Similarity of Subject Matter refers to the use of one or more elements that are common to all of the works in a display arrangement. This can be as broad as using all glazed works, all pictures in gold frames, or all landscapes; it can be as narrow as using all works by the same artist or all works of the same kind of flower. In group arrangements, it is desirable to use similarity of subject matter to avoid or minimize the effect of clutter. The purest definition is, of course, to make sure that all works in the display are of similar subjects.

Size refers to the physical size of a work of art, either its two-dimensional area or its three-dimensional volume or mass.

Stopper means a work of art with a strong counterdirection placed to balance a group of works that have the same compositional direction. The stopper directs the viewer's attention back to the arrangement.

Subject Matter means the specific subject represented by the artist.

Surface Reflectivity refers to the high or low degree of reflection caused by light striking the surface of pieces of decorative art, especially silver or other metalwares, glassware, and glazed ceramic ware. Although high surface reflectivity tends to make pieces glitter and dazzle, it also makes a display case look fuller than it actually is.

Tabletop Display refers to the use of a table with a sunken top for display purpose or the actual display within such a table.

Textural Handling is the artist's ability to create the illusion of actual texture on a two-dimensional surface or the real texture created by the artist on the surface of a sculpture.

Top-of-the-Market Price means the premium price paid for the work of an artist.

Ultraviolet Light refers to certain light rays of extremely short wavelength lying beyond the violet end of the visible spectrum. The standard abbreviation for ultraviolet light is *UV.* UV light is one of the major factors that causes damage to artworks, especially in rooms where direct sunlight does not enter and people leave the windows unshielded by curtains. It causes an even, overall bleaching or fading to all colors but particularly to those colors used in dying paper and cloth. It is also produced by most commercially available fluorescent light tubes, and in offices where original artworks are displayed, fluorescent lighting should be shielded with UV filter screens placed over the tubes. Titanium white in wall and ceiling paint is helpful because it absorbs rather than reflects UV light.

Visual Arts refers to fine arts and decorative arts as opposed to other forms of art such as ballet, music, drama, and literature.

Visual Balance is achieved by designing an arrangement or adjusting the positioning of a work of art on a wall or other placement without making actual measurements with a ruler but estimating the effect by vision. The term also means to create an arrangement that produces a balanced effect between the visual masses of its parts.

Visual Clutter is the haphazard placing of objects without plan, forethought, measurement, or intent. The result overwhelms the viewer and submerges one in confusion. It is extremely uncomfortable for one to be surrounded by visual clutter. It actually produces an insane environment and can cause physical pain and distress.

Visual Depth is the illusionary effect of depth rendered by an artist on a two-dimensional plane (see "Depth of Field").

Visual Mass is the apparent solidity of a work of art created by the choice of color, texture, shading, line work, and brushwork. Visual mass can also include the effect of the frame in occluding or stopping one's view. It is the apparent or real volume of space that a work of art seems to occupy (see "Visual Weight").

Visual Weight is related closely to, but differing slightly from, visual mass. Visual weight is the degree of heaviness or lightness a work of art seems to possess. Visual weight suggests to the viewer the more aggressive action of visually testing the weight of the art object, while visual mass is concerned with the space the object occupies.

Vitrine refers to a bottomless glass or plexiglass box placed over one or more objects of art as a protective shield for display purposes.

Vitrine Case refers to a glass- or plexiglass-fronted display case with one or more shelves used to hold objects within it. The case can have glazed sides, top, and bottom, but it is placed against a wall and normally has a solid back. It is usually lit from within. *Vitrine* is derived from the French *vitre* (glass).

Wood-Pulp Paper refers to paper products made from the cellulose fibers of wood. It has a high acidity content and rapidly becomes brittle, dry, and crumbly within a few years. When used for matting paper or board, the acidic fumes emitted by wood-pulp paper chemically burn any other paper product placed adjacent to it. Physical evidence of this chemical burning process is noted by brown splotches or streaks the color of strong tea appearing on a work of art on paper that is matted with wood-pulp paperboard. Dealers and conservators call these chemical discolorations *burning*. The only way to remove burning is to bleach the paper upon which the burning appears. This is an extremely hazardous repair method, especially on watercolors where the color of the work of art may easily bleach out also, irreparably damaging the work of art.

Wood-pulp paper was first devised in the 1830s. By the end of the century, many works of art, such as steel engravings, were made on wood-pulp paper, and rag-paper prints were glued down on wood-pulp paperboards. Until very recently, works so created could not be saved from eventual disintegration as the wood-pulp paper crumbled into dust, turning dark brown in the process.

A new process has been developed which can de-acidify this wood-pulp paper (see "Wei To Associates, Inc.," in "Services and Products, Acid-Free Paper Products").

✉ The following is a list of sources and services to which anyone may turn when in need of an answer to a special problem that may arise in relation to the proper display of artworks, the care and protection of owning artworks, and the general safe maintenance of artworks. At the head of the list are a number of regional and national organizations to which one may apply for answers to questions.

Inclusion of the name of a company or organization in this directory does not mean that the author or publishers endorse the company or its product or service and does not in any way guarantee the quality of the product or service offered.

ORGANIZATIONAL SERVICES

There are organizations in the United States that provide services to private individuals on virtually every aspect of contemporary life. In reference to private citizens owning, buying, collecting, and showing works of art, the following organizations can be contacted for assistance, publications, and possibly answers to your specific questions.

American Association of Museums
1225 Eye St., N.W.
Suite 200
Washington, D.C. 20005
202/289-1818
FAX: 202/289-6578
The American Association of Museums (AAM) is the professional organization of all kinds of museums throughout the United States. Its basic purpose is to serve the member museums. However, it can direct your queries to the museum nearest you that may be able to assist you in solving your problem.

American Association for State and Local History
172 Second Avenue North, Suite 202
Nashville, Tennessee 37201
615/255-2971
The American Association for State and Local History (AASLH) provides technical assistance, publications, workshops, and seminars primarily for and through its member organizations and museums. However, like the AAM, it has individual memberships available for purchase by the general public, and it, too, can refer inquiries to the nearest local museum that may be able to help you in solving your special problem.

Art Dealers Association of America, Inc.
575 Madison Avenue
New York, New York 10022
212/940-8590
This organization was initially established to create and maintain uniform and ethical standards of operation for its member dealers and has since become one of the best sources in the country for up-to-the-minute appraisals on works of art through its members. It offers a number of services for which private individuals may apply, including a theft notice hotline.

American Institute for Conservation of Historic and Artistic Works (AIC)
Klingle Mansion
3545 Williamsburg Lane N.W.
Washington, D.C. 20008
202/364-1036

International Foundation for Art Research, Inc.
46 East 70th Street
New York, New York 10021
212/879-1780
One can become an individual member of this organization, receive its magazine ten times a year, attend its lecture series, and purchase its services, including authentication of works of art for owners. A prime service IFAR offers is an art theft hotline.

National Fire Protection Association
470 Atlantic Avenue
Boston, Massachusetts 12210
This organization publishes small, concise, and extremely informative booklets designed to inform the reader on how to minimize the damage caused by fire as well as how to alleviate, as much as possible, the causes of fire. These booklets are available for purchase by writing to the above address.

In addition to the above listed organizations, there are, in most cities with a population of 50,000 and over and in most state capitals, government-operated arts councils, funded by both state and federal agencies. One of the services of these arts councils is providing information on local art resources for the general community.

SERVICES AND PRODUCTS

MAJOR INTERNATIONAL AUCTION HOUSES

Christie, Manson & Woods International, Inc. (usually called "Christie's")
502 Park Avenue
New York, New York 10022
212/546-1000
FAX: 212/980-8163

Sotheby's
1334 York Avenue
New York, New York 10021
212/606-7000
FAX: 212/606-7107

These two auction houses handle probably a majority of Fine Arts sales worldwide. The catalogues each house publishes for each sale provide one of the best scholarly sources for obscure and lesser known information on both major and minor artists, as well as the usual major information on these artists. The catalogues are quite often fully illustrated. They also provide an up-to-the- minute source on monetary valuations.

APPRAISERS

Upon written request, national associations of appraisers provide names of appraisers in one's geographic area. The following organizations are the chief ones in America:

The American Society of Appraisers
Dulles International Airport
P.O. Box 17265
Washington, D.C. 20041
703/620-3838

The Appraisers Association of America, Inc.
60 East 42nd Street
New York, New York 10017
212/867-9775
The American Society of Appraisers requires its members to pass an examination in their area of concentration to qualify for certification; the Appraisers Association of America, Inc., requires prospective members to sign an agreement on ethical standards and practices to qualify for certification.

ACID-FREE PAPER PRODUCTS

The following companies manufacture or retail paper and cardboard products that are, by definition, acid-free:

Archivart Products
Division of Heller and Usadan
7 Caesar Place
Moonachie, New Jersey 07074
201/804-8986
800/333-4466
FAX: 201/935-5964
Manufacturer of Archivart acid-free papers, boards, and other products for the conservation of art.

Crescent Cardboard Company
100 W. Willow Road
Wheeling, Illinois 60090
708/537-3400
800/323-1055
FAX: 708/537-7153

Manufacturer of Crescent Board matting. All Crescent Mat Boards are acid-free.

The Hollinger Corporation
4410 Overview Drive
P.O. Box 8360
Fredricksburg, Virginia 22401
703/671-6600
800/634-0419
FAX: 703/898-8073
National and international distributor of acid-free papers and cardboard products for the artist, archivist, and conservator.

Rising Paper Company
Division of Fox River Paper Company
295 Park Street
Housatonic, Massachusetts 01236
413/274-3345
FAX: 413/274-6684
Manufacturer and distributor of acid-free paper and cardboard products for use by the artist, framer, and printer.

Strathmore Paper Company
South Broad Street
Westfield, Massachusetts 01085
413/568-9111
Manufacturer and distributor of a general range of acid-free paper products for the artist and the framer.

TALAS, Division of Technical Library Service, Inc.
213 West 35th Street
New York, New York 10011

✉ SERVICES AND PRODUCTS

212/736-7744
FAX 212/465-8722
National and international distributor of a wide range of archival acid-free paper supplies.

Wei T'o Associates, Inc.
21750 Main Street, #27
Matteson, Illiniois 60443
708/747-6660
FAX: 708/747-6639
Consulting services for preserving archival, library, and museum paper artifacts.

DISPLAY EQUIPMENT
If you know the name of the type of equipment needed, but not the name of the manufacturer or distributor, you can get that information by writing the Editor of

Display World
407 Gilbert Avenue
Cincinnati, Ohio 45202

Kenneth Lynch & Sons
78 Danbury Road
P.O. Box 488
Wilton, Connecticut 06897-0488
203/762-8363
FAX: 203/762-2999
Manufacturer of picture hanging devices and a number of other display tools; also a source for hand-painted metal picture label plaques and gallery devices such as angle tacks, vitrine cases, print cases, and sculpture pedestals.

Multiplex Display Fixture Company
1555 Larkin Williams Road
Fenton, Missouri 63026
314/343-5700
FAX: 314/326-1716
Manufacturer of various sales-gallery display equipment, especially the swinging panel (book type) display system.

Roberts Colonial House
570 West 167th Street
South Holland, Illinois 60473
708/331-6233
FAX: 708/331-0538
Manufacturer of plastic display equipment, including plate stands, vitrine boxes, etc.

FRAME-BACKING BOARDS
Fomebords Company
2211 North Elston Avenue
Chicago, Illinois 60614
312/278-9200
800/362-6267
FAX: 312/278-9466
Distributor of lightweight rigid graphics board for use in mounting and packaging: Fome-Cor® and similar materials. They can inform you about local distributors of these materials.

Monsanto Corporation
800 North Lindbergh Blvd.
St. Louis, Missouri 63167
314/694-1000
FAX: 314/694-8421

Manufacturer of Fome-Cor®, an inert rigid plastic foam sheet laminated with white paper for use in backing paintings on stretchers or for backing objects mounted under glass. Fome-Cor® is available in either 3/16″ or 1/8″ thickness. They can give you information about local distributors upon your request.

LIGHTING PRODUCTS
St. Louis Antique Lighting Company
801 North Skinker
St. Louis, Missouri 63130
314/863-1414
FAX: 314/863-6702
Restoration of antique lighting fixtures and source for reproductions of early twentieth-century fixtures.

Lightolier
100 Lighting Way
Secaucus, New Jersey 07096-1508
201/864-3000
FAX: 201/864-9478

Swivelier Co., Inc.
33 Route 304
Nanuet, New York 10954
914/623-3471
FAX: 914/623-1861
The two companies listed above manufacture track lighting with movable, snap-in fixtures. Each company's products differ slightly from the other's. Most electrical suppliers across America handle their products.

ULTRAVIOLET-FREE PRODUCTS

(It is not possible to screen out, completely, all U-V emission, so that the term "ultra-violet free" is a misnomer. The various films, sleeves, and liquids which manufacturers produce screen out about 97% to 98% of the U-V emissions.)

Verilux, Inc.
626 York Street
Vallejo, California 94590
707/554-6850
FAX: 707/554-8370

MOVERS AND HANDLERS

Most of the large, national moving companies, those which transport general household objects, may have trained personnel to handle shipments of works of art, either as part of one's general household shipment or in a specific shipment.

Allied Van Lines
Special Products Division
300 Park Plaza
Naperville, Illinois 60563
708/717-3688
FAX: 708/717-3396

Mayflower Transit, Inc.
9998 N. Michigan Road
Carmel, Indiana 46032
317/875-1107

North American Van Lines
P.O. Box 988
Fort Wayne, Indiana 46801
219/429-3775
FAX: 219/429-1741

United Van Lines
1 United Drive
Fenton, Missouri 63026
314/326-3100

There are also companies which specialize in packing and moving only works of art. These include the following:

Cirker's Hayes Storage Warehouse, Inc.
305 East 61st Street
New York, New York 10021
212/838-2525
FAX: 212/486-3188

Eagle Fine Arts
401 Washington Street
New York, New York 10013
212/966-4100
FAX: 212/966-4828

Fine Arts Express Southwest, Inc.
7440 Whitehall
Fort Worth, Texas 76118
817/589-0855
FAX: 817/284-1376

Ollendorff Fine Arts
21-44 Forty-Fourth Road
Long Island City, New York 11101
212/936-7200
800/221-6500
FAX: 718/937-6274

There are also a number of fine-art shipping consultants and custom brokers, among which is the following:

W. R. Keating & Co.
150-16 132nd Avenue
Jamaica, New York 11434
718/481-5400
FAX: 718/528-0871

◣ SELECTED READINGS

◣ The following publications provide further information for anyone wanting to broaden his or her knowledge and understanding on matters relating to the display, handling, owning, protection, and usage of original works of art. Although most of the works listed here are still available in print, some are not. For those which are not in print, consult the local library reference room or a good used-book store.

GENERAL ART HISTORY

For those who want to learn more about the history of art, there are two general art history texts that are used in many of America's universities and colleges.

Janson, H. W. *History of Art*. Abrams and Prentice-Hall, 2nd edition, 1977.

De la Croix, Horst, and Richard G. Tansey. *Gardner's Art Through the Ages*. 6th ed. New York: Harcourt Brace Jovanovich, Inc., 1975.

HELPFUL PAMPHLETS

The U. S. Department of Agriculture publishes a large number of pamphlets on home methods of handling problems in its "Home and Garden Bulletin" series. One such pamphlet, for example, is "How to Prevent and Remove Mildew." These paperback pamphlets are available through the U. S. Government Printing Office for a nominal charge.

The National Fire Protection Agency (see listing in "Services and Products") also pub-lishes helpful pamphlets on various problems and solutions in combating the hazards of fire and alleviating and removing potential fire sources or causes. These are available from the association for a nominal charge.

SPECIFIC WORKS ON COLLECTING AND CONSERVATION

American Association of Museums, The Official Museum Products and Services Directory, 1992, Wilmette, Illinois: National Register Publishing Company, 1991. Best source for a very complete listing of the services and products provided nationally for the museum world.

The ARTnewsletter, New York: *ARTnews*.
(ARTnewsletter
5 West 37th Street
New York, New York 10018
212/398-1690)
An expensive but extremely informative eight-page, biweekly report on the international art market. Lists high prices on works sold at auction worldwide, gives in-depth developments on specific artists' markets, and gives news coverage on special international art happenings. Very useful to the collector, appraiser, museum curator, and art consultant.

Bénézit, E(douard). *Dictionnaire des Peintres, Sculpteurs, Dessinateurs et Graveurs*. 3rd edition. Paris: Librairie Gründ, 1976. 10 volumes.
Although written in French, it is quite easy to understand. This is perhaps the prime source for collectors and dealers to check information on the more than 300,000 artists, worldwide, that are listed over the past 2,000 years. Gives as complete as is known biographical data, museum collections, sales prices, and exhibitions.

Bannon, Lois Elmer and Taylor Clark. *Handbook of Audubon Prints*. Gretna, Louisiana: Pelican Publishing Co., 1980.
Gives information on the various editions of Audubon's *Birds*. . . as well as his *Viviparous Quadrupeds*. . . (the Animals). Includes tables listing each print, the 1980 values in each edition, the locale of each print, and the artist(s) who worked on the backgrounds. This is an indispensable resource for anyone who owns Audubon prints. There is or will soon be an updated edition giving post-1990 valuations.

Brommelle, Norman, and Perry Smith. *Conservation and Restoration of Pictorial Art*. The International Institute for Conservation of Historic and Artistic Works, London and Boston: Butterworths, 1978.

Conningham, Frederic A. *Currier & Ives Prints: An Illustrated Check List*. New York: Crown Publishers, Inc., 1975.
Lists virtually every known print made separately or jointly by this nineteenth-century firm; gives pricing as it was in 1975.

The Crafts Report. This is the news monthly for crafts professionals, published by Crafts Report Publishing Company, Inc.
700 Orange Street

Wilmington, Delaware 19801
Contains general information on the business of being a craftsperson, including articles on packing, shipping, photographing, etc.

Dawdy, Doris Ostrander. *Artists of the American West: A Biographical Dictionary*. Chicago: The Swallow Press/Sage Books, 1974.
Lists 300 mostly obscure (but also includes most of the best known) artists who painted western subject matter. As the author states in her introduction, all of the artists were born before 1900.

Dudley, Dorothy H., Irma Bezold Wilkinson, et al. *Museum Registration Methods*. 3d ed. Washington, D.C.: American Association of Museums, 1979.
This is often called the bible of the museum curator. It has excellent information on shipping as well as on recordkeeping.

Goodman, Calvin J. *Art Marketing Handbook*. Los Angeles: Gee Tee Bee Press, 1978.
Perhaps the best such work currently in print. Covers all aspects of commercial sales gallery operations in an easily found order. The author is a management consultant in the arts.

Hambidge, Jay. *The Elements of Dynamic Symmetry*. New York: Brentano's, 1926.

Harris, Helen. "The Master Conservators," *Town and Country*. December, 1980, pp. 210-20; January, 1981, pp. 41-48.
Lists 329 restorers and conservators active in the United States.

Hughes, Bernard, and Therle Hughes. *Small Antique Furniture*. New York: Frederick A. Praeger Publishers, 1958.

Keck, Caroline K. *A Handbook on the Care of Paintings*. New York: Watson-Guptill Publications, for AASLH Press, 1965.
Designed for the layman, this can save money as well as help you protect your art. An excellent resource.

Keck, Caroline K. *Safeguarding Your Collection in Travel*. Nashville: AASLH Press, 1970.

Lang, Rudolph. *Win, Place and Show: Effective Business Exhibition*. New York: Oceana Publications, Inc., 1959.

Mayer, Ralph. *The Artist's Handbook*. New York: Viking Press, 1946.
A gold mine for the collector as well as the artist or conservator. Has an excellent index.

Mayer, Ralph. *A Dictionary of Art Terms & Techniques*. New York: Thomas Y. Crowell Company, Apollo edition, 1969.

The Minneapolis Institute of Arts. *Fakes and Forgeries*. Exhibition catalogue, 1973.
Well-illustrated catalogue of an exhibition devoted to the art of the forger and copyist. Provocative and informative.

Plenderleith, H. J., and A. E. A. Werner. *The Conservation of Antiquities and Works of Art: Treatment, Repair, and Restoration*. London: Oxford University Press, 1971.

Ruhermann, Helmut. *The Cleaning of Paintings*. New York: Frederich A. Praeger, 1968.
Gives philosophical history and ethics as well as technical data. By the former conservator of the National Gallery, London.

Savage, George. *The Art and Antique Restorers' Handbook*. New York: Frederick A. Praeger, 1967.

Stout, George L. *The Care of Pictures*. New York: Columbia University Press, 1948.
Old, but a classic in the field.

Weidner, Marilyn K. "Damage and Deterioration of Art on Paper Due to Ignorance and the Use of Faulty Materials," *Studies in Conservation*. Vol. 12, No. 1, (February, 1967).

Wright, Christopher. *The Art of the Forger*. London: Gordon Fraser, 1984.
Although this book has caused enormous controversy in the art world, the arrangement of the material, research substance, and manner by which the author arrived at his conclusions show an art detective working with dedication. No matter whether or not you agree with the author's conclusions, the book makes fascinating reading.

Zigrosser, Carl and Christa M. Gaehde. *A Guide to the Collecting and Care of Original Prints*. New York: Crown Publishers, Inc. 1969.

➤ INDEX